IMAGES
of America

FORT MYERS BEACH

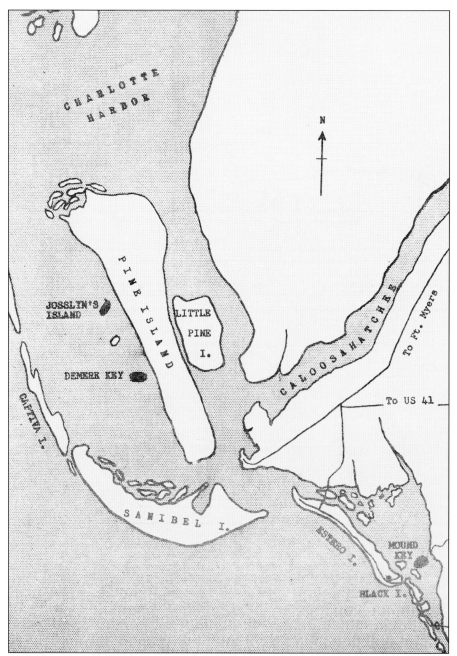

This map, created by Fort Myers Beach historian Rolfe Schell, shows Estero Island—now known as Fort Myers Beach. Many of the other Lee County islands are mentioned in this book. Punta Rassa is located in the small hook-shaped peninsula jutting out south of Pine Island, northeast of Sanibel Island, and northwest of Estero Island. The Estero River is due north of Mound Key. (Estero Island Historic Society.)

ON THE COVER: In 1945, this wooden pier was built on the gulf side of Fort Myers Beach at the end of San Carlos Boulevard and Estero Boulevard. It has become an icon testifying to the island's laid-back lifestyle. (Estero Island Historic Society.)

IMAGES
of America

FORT MYERS BEACH

Mary Kaye Stevens
in collaboration with the
Estero Island Historic Society

ARCADIA
PUBLISHING

Published by Arcadia Publishing
Charleston, South Carolina

Printed in the United States of America

Library of Congress Control Number: 2011928090

For all general information, please contact Arcadia Publishing:
Telephone 843-853-2070
Fax 843-853-0044
E-mail sales@arcadiapublishing.com
For customer service and orders:
Toll-Free 1-888-313-2665

Visit us on the Internet at www.arcadiapublishing.com

To Alisha, Clayton, Skyla, and Cay—my joy and inspiration!
—Mary Kaye Stevens

*To the membership and loyal volunteers who support the
significance of preserving the island history of Fort Myers Beach.
In addition, we dedicate this book to the Town of Fort Myers
Beach and the Historic Preservation Board for their commitment
to preserving the island heritage and natural resources.*
—Estero Island Historic Society

CONTENTS

ACKNOWLEDGMENTS

Hundreds of volunteers have contributed thousands of hours to preserve the history of Fort Myers Beach. Without their dedication and love of local history, this book would not have been possible. Although many of these people have departed, their legacies and contributions live on. The Estero Island Historic Society's archives, photograph collections, and library offered fascinating stories and information about the island's history.

I wish to thank my two editors at Arcadia Publishing, Lindsay Carter and Elizabeth Bray, for their expert guidance. Thank you to Chris Wadsworth, Prudy Taylor Board, Robert Macomber, Diana Ross, Carol Smith, and Peggy Harris for your inspiration and cheerleading efforts! Also, thanks to Michael Heare, Koreshan State Park; Adam Watson, State Archives of Florida; The Southwest Florida Museum of History; and the Southwest Florida Historical Society. There are several people who have paved the way for this book through their research, writing, and enthusiasm for the island's history. Specifically, I wish to thank Pam Fernandez, Tom and Marlene Fernandez, Alvin Lederer, Marci Hallock, Keri Hendry, Roxie Smith, Francis Santini, and Mina and Barney Creech. A special thanks to Robley and Donald Greilick, who were always available to answer questions or search for island photographs.

To A.J. Bassett, I am indebted. During the many hours she drove me around the island, pointing out landmarks brightly colored with her memories, I came to admire her character, pride, and perseverance during happy or adverse times.

Finally, thank you to my family: my grandchildren—Ali, Clayton, Skyla, and Cay; their parents—Karisa and Scott Workman and Staci and Craig Stevens; my parents—Ruth Loeber and Maurie and Dorie Stevens; and my husband, Dan, for providing endless patience, love, and encouragement.

The memories of scores of individuals provide the captions for the majority of these images. Quoted material in the text is from author interviews, except where noted. I can promise that conversations and events are recorded as truthfully as I can relay them. Please understand that despite my efforts toward accuracy, if some factual errors or faulty remembrances are in these pages, they are not intentional.

My gratitude also extends to the following sources: Estero Island Historic Society (EIHS), Koreshan State Historic Site Archives (KSHSA), Fort Myers Historical Museum (FMHM), State Archives of Florida (SAF), and the Southwest Florida Historical Society (SWFHS).

INTRODUCTION

To paraphrase Thomas Edison, "There is only one Fort Myers Beach, and 90 million people are going to find out about it." And they have done just that!

Over the years, the name of the island community has evolved. At first, recognizing the shape of the island, residents called it Crescent Beach. It wasn't long before public outcry came from the east coast of Florida, near Jacksonville, because a town there had previously claimed that name. A 1925 *Fort Myers Tropical News* article referred to the community as Fort Myers Beach. In the following 10 years, the names Crescent Beach and Fort Myers Beach were used interchangeably, but gradually Fort Myers Beach became the island's adopted name. When the community was incorporated, it officially became the Town of Fort Myers Beach. Estero Island remains the geographic location for this playground by the sea.

Centuries before the island community was called Fort Myers Beach, the Calusa Indians flourished here, Ponce de León passed through the area, and commercial fisherfolk lived in ranchos. By the turn of the 20th century, Cyrus Teed had discovered Fort Myers Beach and set up camp in hopes of homesteading the northern end of the island for his band of followers. Later, when pink shrimp was discovered offshore, an influx of shrimpers made the island home. But it was the bridges that brought the tourists, new residents, and wartime populations to Fort Myers Beach. The island became a destination for relaxing for a while; it became known as the place to find some joy in life in a quiet, but friendly place.

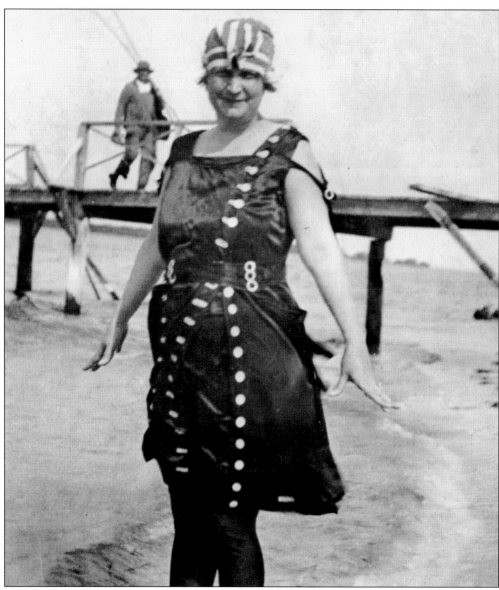

In their book *Early Fort Myers: Tales of Two Sisters*, Alberta Colcord Barnes and Nell Colcord Weidenbach told of trips to Fort Myers Beach in the 1920s. "When we turned off McGregor, the beach access road was more of a trail than a road—sandy, rutted, one-way. Cars would struggle through the powdered-sugar sand and park all up and down the waterfront just above the high-tide line. Every new tide brought in millions of beautiful shells, which piled up in windrows along the beach. The main attraction, of course, was the clear green water of the gulf, usually with a gentle surf and never an undertow. Days at the beach meant a picnic lunch including pineapple sandwiches, Mama's specialty!" In this 1920s image, an unidentified bathing beauty poses in the surf as a fisherman carries his rod and tackle on the pier behind her. (FMHM.)

One

Calusa, Explorers, and a Pirate or Two

By the time the first European explorers arrived in the Fort Myers Beach area, the Calusa Indian empire was well established on Mound Key, with winter camps on Fort Myers Beach. The Calusa tribe's presence on many of Florida's western islands is evidenced by the shell mounds they left behind. Most historians believe that the mounds are kitchen refuse sites, while some offer the theory that they were the ceremonial grounds of the Calusa. Of the three mounds originally on Fort Myers Beach, only the one known as the Mound House site remains today.

Spanish explorers seeking gold and slaves first set sail for Florida in the early 16th century. In 1513, Ponce de León, on his quest for eternal youth, was the first to sail into San Carlos Bay. Pedro Menendez, the rich and powerful founder of America's oldest city, St. Augustine, failed in his attempts to pacify the Calusa Indians of southwest Florida and establish a Jesuit mission on Mound Key. Instead of gold and submissive slaves, the explorers found fierce natives and no treasures.

There is little doubt as to the intensity of pirate traffic along Florida's west coast during the late 1700s and early 1800s. Within the area that became known as the "Mangrove Coast"—the mainland and islands running from Key Largo to Sanibel Island—Fort Myers Beach was not exempt from pirate tales. While some pirate lore is simply fabricated myth, other stories, such as that of Juan Gomez, have family descendents who testify to their validity. The most well-known and beloved island pirate was Captain Rackam, known as "Calico Jack." With stories of buried gold and jewels on Fort Myers Beach and Mound Key, die-hard treasure hunters are ever hopeful and continue to search.

After making landfall on the east coast of Florida on April 8, 1513, Juan Ponce de León skirted the Florida Keys and made his way into Estero Bay. Although it is not recorded, it is probable he and his men made a formal landing on Estero Island during the 22 days he spent exploring the area. Landing either in Charlotte Harbor or Estero Bay, he established a settlement, which was attacked by the Calusa, who drove back the Spanish. During the attack, de León was seriously wounded. He returned to Cuba, where he died from the wounds. Some contemporary historians speculate that de León was searching for a virility elixir rather than a "fountain of youth." (SAF.)

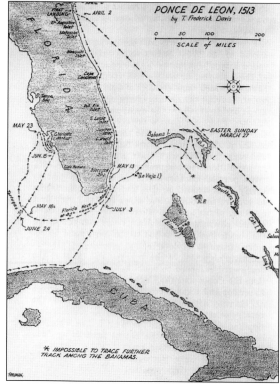

Sailing on ships similar to the ones pictured above, Pedro Menendez de Aviles and his men arrived on the west coast of Florida, probably in the area of Estero Island or Bonita Beach, on February 17, 1566. Menendez is pictured to the right around the time of this mission. During a visit with Carlos, leader of the Calusa Empire, Menendez was presented with Carlos's sister for marriage. Menendez, already married, tried to refuse, but was ultimately forced to accept. The marriage was announced and consummated that evening. Shortly after the union, the bride was sent to Havana, where she was educated, while Menendez left to further explore the west coast of Florida. (Both SAF.)

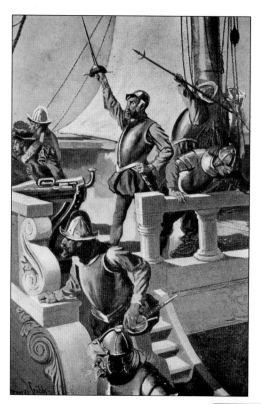

In his controversial book, *De Soto Didn't Land At Tampa*, islander and local historian Rolfe Schell proposed his theory that in May 1539, Hernando de Soto first made landfall on the western shore of Fort Myers Beach rather than Tampa. From there, the crew sailed into the mouth of the Caloosahatchee River, where de Soto stationed his men at Palmetto Point. Historians were fascinated with the way Schell pieced together the 400-year-old bits of evidence pointing to his conclusion. (SAF.)

Although there are no records that Hernando de Soto's men were on Fort Myers Beach, there is evidence they were on Mound Key and most likely visited neighboring Fort Myers Beach as well. Elwin E. Damkohler told Rolfe Schell of an 1890 incident that occurred on Mound Key when he was 12 years old: "I was with the two sons of Frank Johnson and we found a brass framed picture of a man's bust dressed in dark clothes. A note to de Soto's captain was also found. It told of two crosses, one of gold, one of silver, a man's gold ring, three small bells connected by a silver chain and one gold bar and gold beads." If this is true, it definitely ties de Soto to the area. (SAF.)

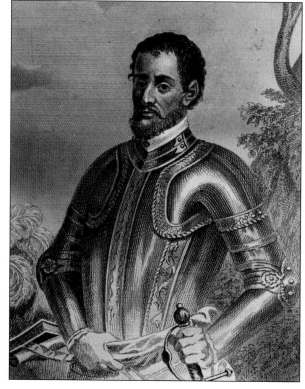

When Smithsonian anthropologist Frank Hamilton Cushing visited Estero Bay in 1895, he discovered that a series of enormous elevations and imposing mounds once covered Mound Key. Perhaps serving as a burial mound, one of the mounds, measuring 150 feet at its base, had a flat-topped crest that gave it a pyramidal appearance. According to Florence Fritz, author of *Unknown Florida*, "By the time of Cushing's visit, the burial section had been plundered, removing Calusa skeletons, 'Venetian beads,' small gold and silver ornaments, and sheets of copper." (EIHS.)

Portuguese missionary Antonio Fernandez journeyed to America with his family in 1898. Juan Gomez, the captain of the ship transporting the Fernandez family to Tampa, abandoned Antonio and his family on Estero Island, hundreds of miles south of their destination. Juan Gomez took all of the Fernandez family's possessions—even their clothes. With a wife and three young daughters, Fernandez (shown here years later) was without food, water, money, or much hope of survival. Mound Key resident Frank Johnson happened upon the family and rescued them, providing food and shelter. (Fernandez collection.)

Rosa was the second daughter of Antonio and Mary Fernandez, who immigrated to Florida from Portugal in 1898. The family was abandoned on Fort Myers Beach but rescued by Frank and Mary Johnson, of Mound Key. Rosa spoke of the palmetto-thatched home she and her family lived in until her father could supply better. She married Joe De Soto in 1920 and is pictured here with her nine-month-old son Walter. (Fernandez collection.)

The first known honeymooners in Lee County spent their romantic getaway on Fort Myers Beach. After marrying in Ireland in the early 1700s, newlyweds Anne McFarren and Calico Jack set sail for the Florida Keys. Before reaching Key West, the ship ran into a storm and was damaged. Off course and needing to repair the ship, they found refuge on Fort Myers Beach. While the crew made necessary repairs, McFarren and Calico Jack made a cozy room on the island using native timber and palm fronds for a roof. For two weeks, they spent their days swimming, sunning on the beach, and gathering seashells. In the fall of 1720, the husband and wife were captured and tried for piracy. Both were convicted of piracy and Calico Jack was hanged. Because she was pregnant, McFarren was spared. In this c. 1895 image, a lone woman walks along Fort Myers Beach, which had changed little since the honeymooners' visit over 100 years earlier. (KSHSA.)

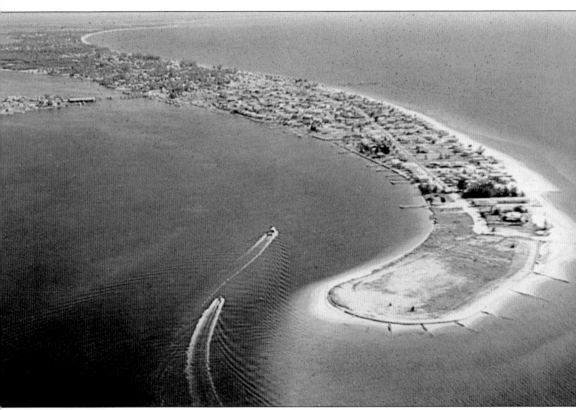

Bowditch Point, on the northern tip of Fort Myers Beach, was part of the Calusa empire and the site of several shell mounds until the early 1900s, when road builders used the shells to improve the sand roads. In the late 1800s, the channel running between the island and the mainland was used by schooner captains to ship cattle from Punta Rassa to Cuba. The government owned a lighthouse/quarantine preserve at the north end of the island. According to Leroy Lamoreaux, author of *Early Days on Estero Island*, "Cyrus Teed, leader of the Koreshan Unity, coveted every bit of land his eyes rested on. He put a little house with a squatter in it on this land. Then he had some of his people go to work on the government to see if it couldn't be changed back to homestead land. He finally gave it up and moved the house off the land." Bowditch Point is pictured here in the late 1950s. (EIHS.)

Two

HOMESTEADERS AND FISHERFOLK

Following the demise of the Calusa, commercial fishermen—called Cuban fisherfolk—began to establish seasonal fishing camps, known as ranchos, in the area. The Fort Myers Beach rancho was located near the south end of the island. The fisherfolk built thatched huts, made fishing nets from the fine fibers within yucca plant fronds, and built drying racks for their net spreads. Their catches of cured mullet roe and drum were shipped to Cuba. In Estero Bay, commercial fishing houses perched on pilings served the fishing community. Supplies were brought in and fish and vegetables were loaded onto "run boats."

In an effort to encourage settlement, the Homestead Act was passed in 1862. Fort Myers Beach was surveyed in 1875 and platted in 1876, enabling the deeding of properties.

Within a short time, advertisements in newspapers around the world read: "Come to Florida! Come to Estero Island! Come and get your free land! Live on this land five years; clear it; farm it; improve it—and it is yours, free and clear!" Pres. Benjamin Harrison granted the island's first homestead to Robert B. Gilbert in 1889. The names of many old timers are remembered as "homesteaders," but for various reasons most of them failed to "prove up" on the land.

A piece of land was proved by Albert A. Austin in 1914 under Pres. Woodrow Wilson. Leroy P. Lamoreaux, the last of the homesteaders, is said to have commented, "Al was an Indiana glassblower who came down here to join the Koreshan Unity, and judging by some of the things he told me, I think getting away from his wife was an incentive." Although early settlers chose to make Fort Myers Beach home for various reasons, a number of commonalities became apparent—the sound of the surf, the tropical temperatures, and the opportunity for free land.

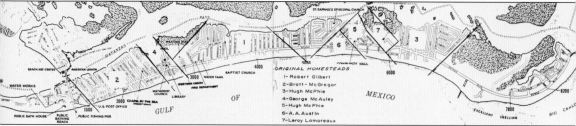

Until about 1895, Fort Myers Beach (Estero Island) remained uninhabited except for fishermen, smugglers, and outlaws. Most homesteaders lived in primitive palm-thatched log homes called cheekees and traveled around the waterways in small boats. The first to file for homestead rights on the island was Robert B. Gilbert, who was granted a patent in May 1898. The homestead included "Shell Mound," which was the Gilbert homesite. In August 1899, a patent for about 150 acres was granted to Ambrose M. McGregor, for whom McGregor Boulevard was named. In November 1899, Hugh McPhie proved up about 112 acres. Other homesteaders followed—George McAuley in 1906, A.A. Austin in 1914, and, lastly, Leroy Lamoreaux in 1918. The Koreshan Unity obtained the southern end of the island in 1898. This map shows the homestead properties overlaying later island development. (EIHS.)

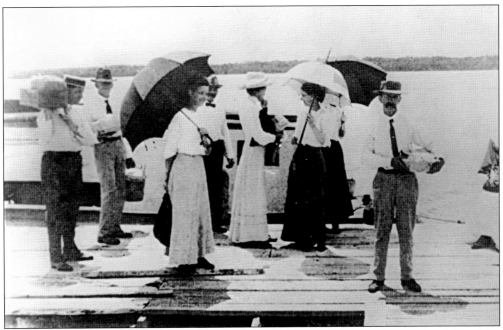

Fort Myers Beach and Estero Bay pioneers lived in relative isolation from the mainland. Until the completion of the swing bridge in 1921, islanders relied on water transportation from "runboats" (fast, shallow-draft boats), skiffs, steamers, and sloops. In this c. 1915 photograph, one such boat is docked at Estero Island as an unidentified group disembarks. A trip to Fort Myers, the nearest city, took several hours. (KSHSA.)

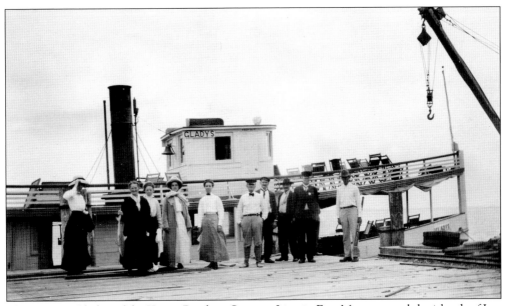

The steamer *Gladys*, of the Kinzie Brothers Steamer Line in Fort Myers, served the islands of Lee and Charlotte Counties, including Punta Rassa, from 1911 to 1936, carrying passengers, mail, freight, and crates of fruits and vegetables. The *Gladys* is shown here around 1915 at the Punta Rassa dock, with a group of passengers waiting to board. (KSHSA.)

Punta Rassa, located at the mouth of the Caloosahatchee River, was the main docking area for passenger steamships that connected the southern Lee County islands, including Fort Myers Beach, with the rest of the world. The passenger area also contained cattle chutes, used for loading cattle onto barges heading for Cuba. This early 1900s image depicts cattleman Jacob Summerlin's home on the beach at Punta Rassa, complete with "net spreads." (FSHSA.)

The earliest Fort Myers Beach homesteaders relied on horses for land transportation. In the dry winter months, the roads were powder-dry sand, while the rainy summer season meant standing water over most trails. A group of people stand among the saw palmettos with a horse and carriage in this pre-1900s photograph. Only Alfred Christiansen (fourth from left in front row) and Wilton Hoyt (next to the horse) are identified. (KSHSA.)

In 1882, Gustave Damkohler—shown here in a 1902 portrait—became one of the first homesteaders in the Estero Bay area. When his original plan to grow pineapples failed, he tried trapping turtles, selling turtle eggs, and commercial fishing. All were short-lived endeavors. Disheartened, he contacted Cyrus Teed about building the Unity Settlement in the Estero Bay area, and Teed (later named Koresh) agreed to build the settlement there. Eventually, Teed convinced Damkohler to give his 160-acre property to the Unity as a gift. (KSHSA.)

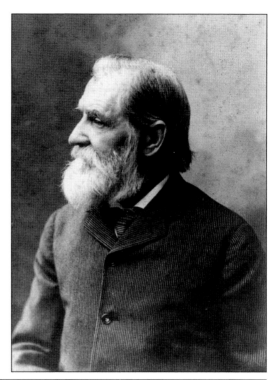

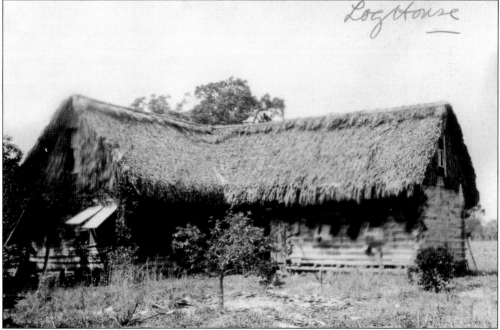

Early southwestern Florida settlers often lived in palmetto-thatched homes called cheekees. Palmetto fronds were cut from the native plant and attached to the roof. Fronds could also cover a wooden house frame or, in some cases, rough-hewn timbers, as shown in this photograph of a home built in the 1890s by a Koreshan Unity member. The frond roof offered protection from rain and sun while allowing air to circulate for ventilation. (KSHSA.)

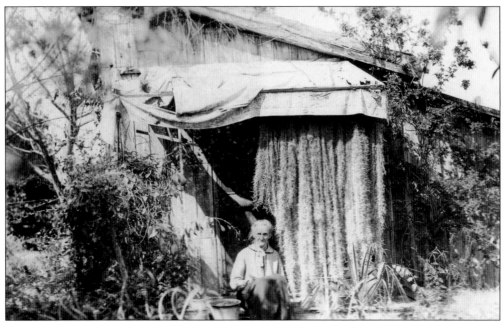

In a 1999 interview with Eleanor Case Grace, granddaughter of Milia Streeter Case, conducted by Joyce Ratliff, Mila Case was identified as the woman in this 1906 photograph. The building was the family's temporary living quarters while a small Tudor cottage was under construction. Note the strands of Spanish moss hanging around the perimeter of the stoop's roof. (KSHSA.)

The first housing development on the island was started by Henry (known as Harold) Carlton Case in 1911. The property was located on Connecticut Avenue and was about a mile and a half wide. Milia Case, wife of Harold Case, stands in front of their home, known as the Mound House, built in 1909. Bricks for the unusually modern home were delivered by boat. (KSHSA.)

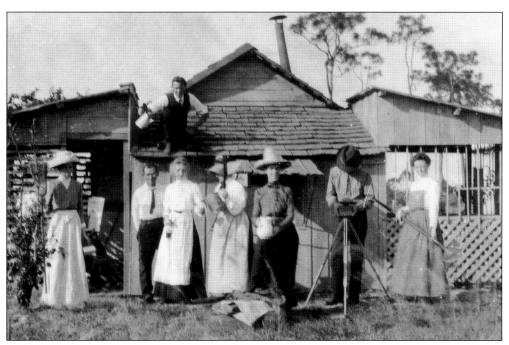

It is believed that this group of unidentified people is standing in front of some of the original Koreshan buildings on the south end of Fort Myers Beach. Enjoying the drama of posing for the camera, some of the subjects hold garden tools while a man perched on the roof pretends to pour the contents of a coffee pot over the head of the man below. (KSHSA.)

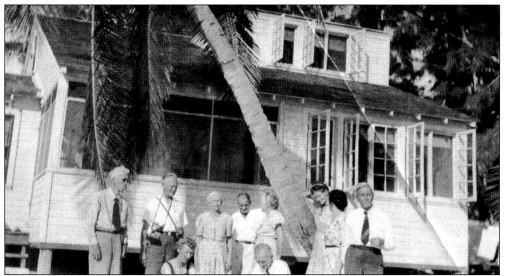

In a 1990 interview conducted by Martha and Jack Remington on behalf of the Fort Myers Beach Oral History Program, Evelyn Horne, then 79, commented, "I miss the old places and the old friends. I can still stay at the Rising Tide Cottage for vacations with the Koreshan Unity. We all [past Koreshan Unity members and associates] can go. It's right next door to the Red Coconut and across the street from the Gulf View Shop. Mrs. Ruth Brame was a good friend. She always remembered my birthday." Vacation guests at the Rising Tide included Thomas Edison. A group of unidentified people are pictured here in front of the Rising Tide Cottage in October 1948. (KSHSA.)

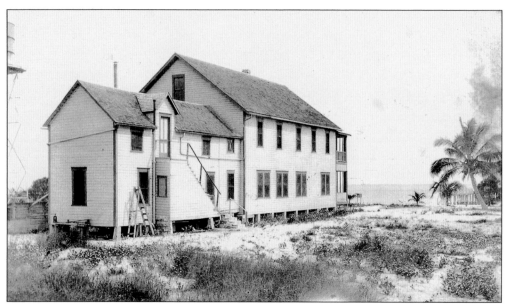

Dr. William Winkler and his wife built the first hotel on Fort Myers Beach, where rooms cost a dollar per night, later renaming it the Beach Hotel. William Winkler's nurse, Martha Redd, inherited Winkler's tract of land adjacent to the hotel that runs to the bay. In 1979, her property was purchased to make Matanzas Pass Preserve. In 1995, the Estero Island Historic Society complex moved to land adjacent to the preserve. The original Winkler hotel is pictured here as it looked upon completion in 1913. (EIHS.)

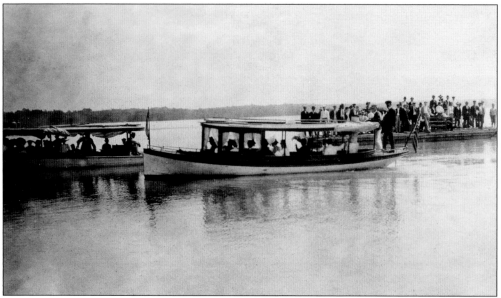

Day trips to neighboring islands were a rare treat for members of the Unity. Sometimes they would travel in a fleet of pleasure boats to places like St. James City's general mercantile on Whiteside's Pier, followed by a meal at the ritzy San Carlos Hotel. A short cruise took the group to Sanibel Island, where they could pick up fresh produce at Bailey's, or, after docking on the bay side, enjoy a buggy ride across the Sanibel Plain for a stay at the Palms Hotel. For a big city outing, Fort Myers was the only option. (KSHSA.)

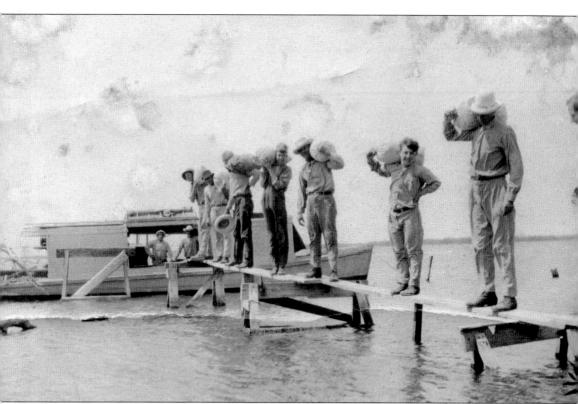

Homesteaders in the Estero Bay area included members of the Koreshan Unity. Unlike the sandy Fort Myers Beach, Mound Key was unusually fertile, and the homesteaders were able to grow almost anything, even in the face of the deadly winter freezes of 1894 and 1899, hurricanes, and drought. In this c. 1910 image, Koreshan farmers load produce onto *The Estero*, docked at the end of the "pier." (KSHSA.)

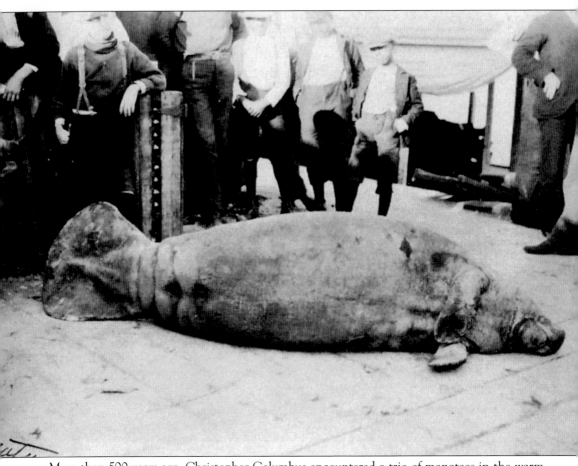

More than 500 years ago, Christopher Columbus encountered a trio of manatees in the warm waters of the Atlantic and wrote in his ship's log: "Saw three mermaids. They were not as beautiful as they are painted." In a 1916 issue of the monthly Koreshan publication, *The Flaming Sword*, the Community Current Events column contained an account of a sea monster on the beach: "The creature was all of twenty feet long, about five feet across the body, with a broad, flat tail, something like an airplane rudder. The head was fully three feet long and two feet wide, tapering into a long bill resembling that of a seagull in shape . . . There were no teeth and the eye sockets were as big as saucers." The unidentified beached sea creature, seen here, perplexed Fort Myers Beach homesteaders. (FSHSA.)

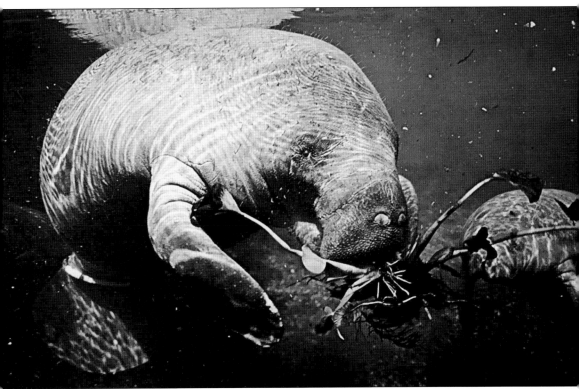

Though they thrive in Florida waters, manatees are rarely seen in the wild. While the large, jowly, thick-bodied creature is hardly the most exquisite inhabitant of the sea, manatees remain among the most fascinating and elusive of sea creatures. Estero Bay and the canals of Fort Myers Beach are among the few places manatees can be seen in their native habitat, as shown in this image. During the winter, manatees congregate in warm water, such as at the Lee Power and Light facility up the Caloosahatchee River. (SAF.)

Runboats, like the one pictured above, provided a lifeline for commercial fishermen and islanders during the early 1900s. Skimming Charlotte Harbor, Pine Island Sound, and Estero Bay, the boats delivered ice and supplies to fish houses, then loaded the local catches for shipment by train out of Punta Gorda, located on the north shore of Charlotte Harbor. The Punta Gorda Depot was the closest railroad depot until the Coast Line Railroad opened depots on the Fort Myers extension on May 10, 1904. Passengers connecting with the mainland sat among the cargo and fish as space allowed. One of the busiest docking areas was at Punta Rassa. As bridges were built to the islands, the fish houses and run boats were replaced with trucks. An Estero Bay fish house and a dock with nets spread are pictured below. (EIHS.)

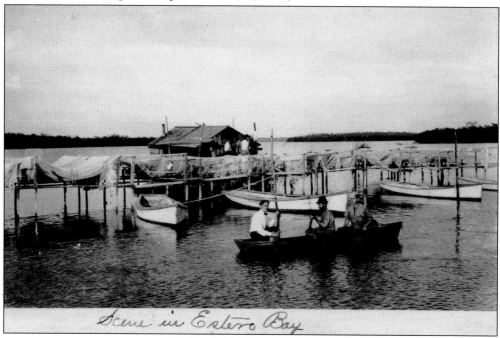

Scene in Estero Bay

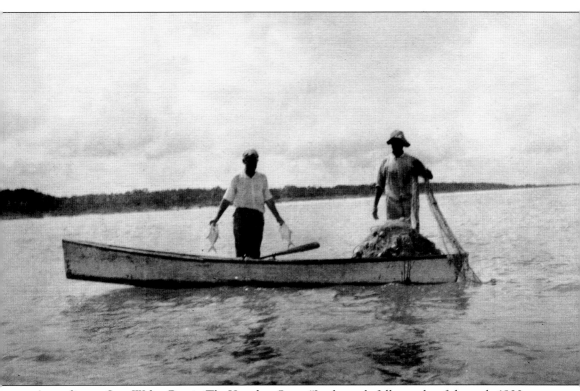

According to Sara Weber Rea in *The Koreshan Story*, "In the early fall months of the early 1900s, when mullet massed in great schools prior to spawning, a nightly diversion was 'fire fishing.' A wire basket of blazing pine knots was affixed to the bow of a boat, and several skiffs were hitched astern. Everyone clambered aboard for a trip in the dark of the moon. Schools of fish, seeing the glaring light from the pitch pine flares, would immediately begin to jump high out of the water in all directions. It resembled a display of fireworks, some landing on nearby river banks and many on the boats. Excitement ran high, as large fish struck with some force and kept everyone dodging to avoid being hit. It was reported that one night 166 mullet jumped aboard and were cleaned on the way home." In this 1910 photograph, Estero Bay fisherfolk pull their nets into a small fishing boat. (KSHSA.)

Commercial fishing was the primary livelihood for generations of Estero Bay fisherfolk. The first blow to the industry came when the Salt Water Fish Bill, which regulates and protects the saltwater fishing industry, was signed by Gov. Park Trammell in 1915. Some eight decades later, in November 1994, 72 percent of Florida voters chose to enact a constitutional amendment banning net fishing, effectively ending a way of life for many commercial fishermen. The ban outlaws the use of both gill and entangling nets in state waters and went into effect in July 1995. In the following years, few could afford to live as commercial fishermen; some turned to crab traps or became charter captains. It remains unclear how much longer the commercial fishing industry can count on the waters of Estero Bay for sustenance. In this 1940s image, an unidentified commercial fisherman uses a gill net to encircle a school of mullet. (EIHS.)

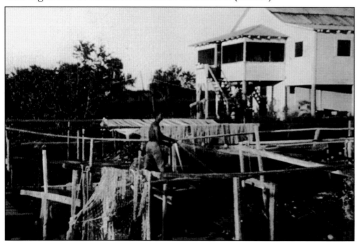

Early commercial fishermen used cotton nets, which required special care. Each time the nets were used, they had to be washed and rinsed in limewater to prevent rot. Then, the nets were spread across wooden racks to dry. This 1940s photograph shows the "net spreads" of Cyril Santini behind his family's canal home. (Santini collection.)

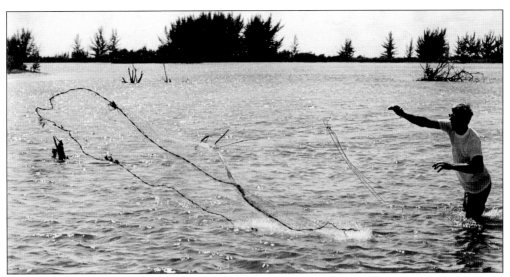

Monofilament cast nets have weights that spread the net in a circle, sinking it to the bottom and allowing the fish to be hauled in. An unidentified fisherman casts his net in Estero Bay in the 1970s, just as early fisherfolk did in the 1800s. (EIHS.)

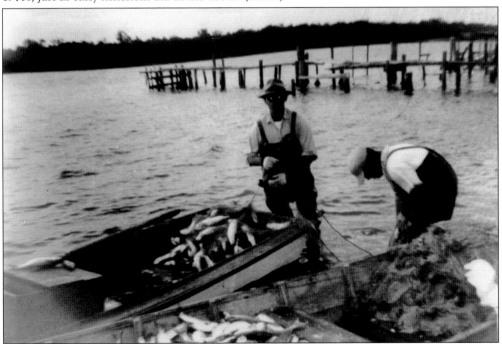

Joe George Fernandez was born on February 22, 1900, on the south side of Mound Key in Estero Bay. His parents, Mary and Antonio Fernandez, came from Portugal. As told by Joe George Frenandez's son, Tom, in *Beside the Still Waters*, "When he was a baby Grandpa would wrap Daddy up in a blanket and put him under the bow of the boat and take him fishing. Daddy told me that he quit attending the Damkohler School on Mound Key in the third grade and he never went back because he found fishing to be much more to his liking." Commercial fisherfolk Joe Fernandez, left, and Joe E. "Bud" Fernandez, right, are pictured here around 1940 bringing in 1,000 pounds of mullet in their nets. (Fernandez collection.)

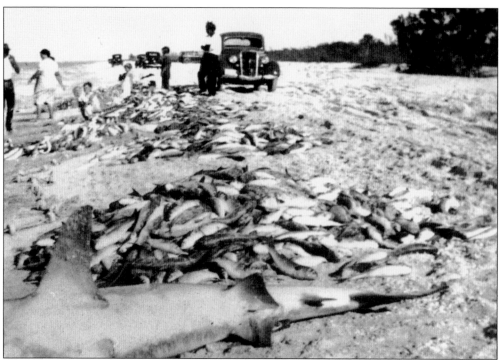

Red tide is an algal bloom, common on Florida's west coast, that causes the water to appear reddish in color and often killing fish. In an interview with Robert Edic, Mary Weeks, an early resident of Estero Bay's commercial fishing community, recalled, "The first red tide I remember was right after the war. Dead fish just piled up." This 1940s photograph shows an attempt to clean the beach of dead fish following a red tide bloom. (SWFHS.)

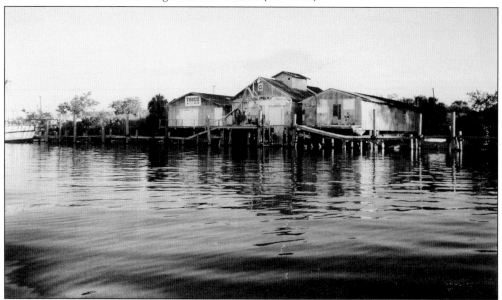

The Fisherman's Wharf was a complex of buildings including an ice house and shrimp docks on San Carlos Island. Once the hub for the shrimping and fishing industry, the buildings stand in disrepair in this 1960s image. (EIHS.)

Three

THE KORESHAN UNITY

The Koreshans were a unique group of late 19th-century pioneers led by Dr. Cyrus Teed. Following his service in the Civil War as a medical doctor, Teed received much attention for his strong beliefs in celibacy, communal living, and the equality of men and women. According to *The Koreshan Story*, by Sara Weber Rea, when Teed was 30 years old, "one night while he was in his laboratory he fell into a trance and a beautiful woman appeared to him in an aura of purple and gold light. Dr. Teed reported that during the time of her appearance she revealed many universal truths to him which shaped his beliefs and formed the tenets of Koreshan Universology." Not long after this "illumination," Teed adopted the name Koresh (Hebrew for "Cyrus"), and so began the Koreshan Unity.

In September 1888, Teed founded the Koreshan Unity in Chicago. As the Illinois membership grew, he chose Lee County as an additional location for turning his utopian dream into a reality. Koreshan members, including Leroy Lamoreaux, A.A. Austin, and Robert B. and Rose Welton Gilbert homesteaded Fort Myers Beach properties, providing the Unity with ownership of the entire south end of the island. In addition, the Unity acquired large connected landholdings on the mainland, as well as title to most of a valuable inner island in Estero Bay known as Mound Key. At one point the Unity owned over 7,000 acres.

In 1893, Teed and other followers began construction of the settlement that was to become a large communal city, a "New Jerusalem," on the banks of the Estero River near Estero Bay. Members of the unity had the option of two different memberships: The Religious Order or the Cooperative Order. Those who were part of the Religious Order pledged celibacy, donated all personal property to the Unity, lived within the Unity settlement, and used their talents to build the New Jerusalem. Those who joined the Cooperative Order could live outside the settlement, maintained their original family unit, and worked in the Koreshan Unity industries. Several members of the Cooperative Order lived on Fort Myers Beach, operating several recreational houses, a boat works, and a sawmill on Fort Myers Beach. For many members, the New Jerusalem became a test of courage. Their willingness to leave the comforts of city life and join Teed in a tropical wilderness was evidence of their belief in him and his teachings.

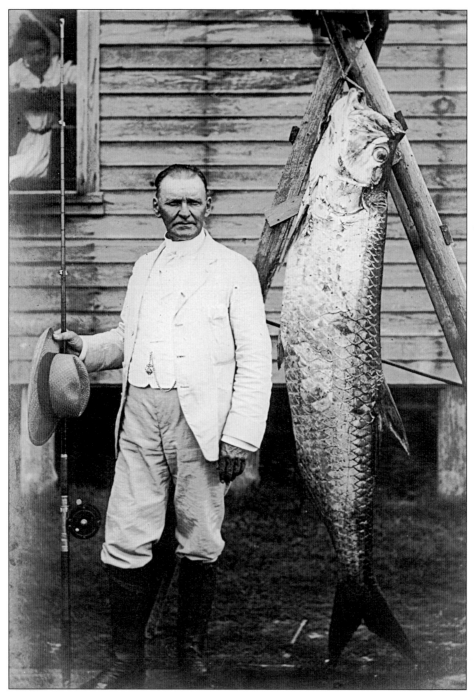

Cyrus Reed Teed was born on October 18, 1839. Before becoming a religious leader, he was an eclectic physician and alchemist. In 1869, claiming divine inspiration, he changed his first name to "Koresh" and proposed a new set of scientific and religious ideas he called Koreshanity. His charismatic personality attracted many wealthy followers who ultimately gave all of their possessions to the Koreshan cause. In 1893, he and his followers arrived in Florida to set up a commune. (KSHSA.)

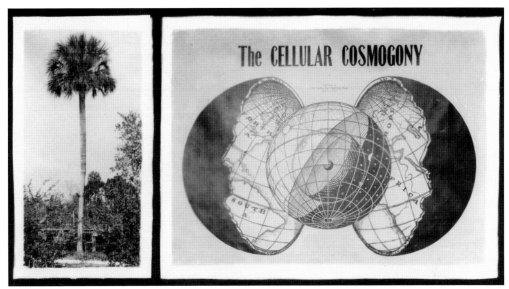

Following a divine revelation, which he received in the autumn of 1869, Cyrus Teed believed that Earth is a hollow cell or sphere that is concave rather than convex, as shown in this illustrated model. Furthermore, Koreshans believed that the sun, moon, and stars were inside this globe and that man lived on an inner crust. (KSHSA.)

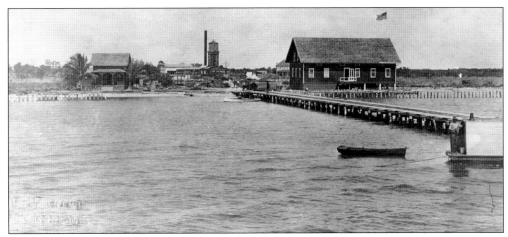

Cyrus Teed first visited Southwest Florida in 1893, meeting with Edgar E. Whiteside of St. James City about purchasing Pine Island property for the expansion of the Unity. Teed's first choice of location was St. James City on Pine Island, north of Fort Myers Beach. When Whiteside's asking price for the property was prohibitive, Koresh set his sights on Fort Myers Beach, where land was "dirt-cheap." Teed was contacted by Gustave Damkohler about the Estero property, where the Unity eventually settled. This image shows the Whiteside Wharf around the time of Teed's visit. (SAF.)

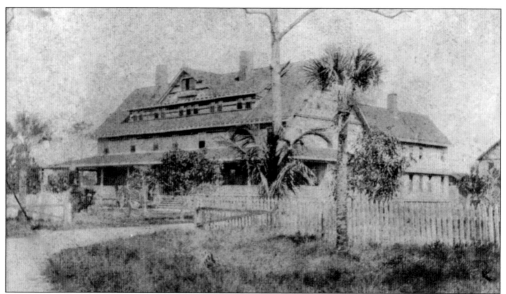

The Koreshan Unity purchased the San Carlos Hotel in St. James City as a site for their planned World College of Life on Pine Island. Built in 1886 by the St. James-on-the-Gulf resort company to attract tarpon fishermen, the hotel, along with the company, went bankrupt in the early 1900s. However, shortly after the Koreshan Unity purchase in 1904, the hotel burned down on July 26, 1905, while it was being remodeled. (SAF.)

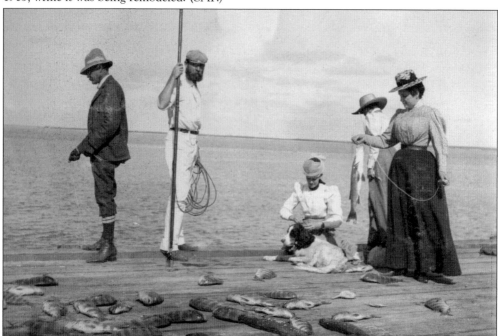

This group of Koreshans shows off their catch around 1910. Several sheepshead are on the dock, and the man in the center is holding what appears to be a gig or something used for spearing fish. The man at left has a line in the water, but no pole. At the time, fish were so plentiful that it was said all a fisherman had to do was dangle a line with a weight and a hook and, as fast as he could drop it in the water, he would pull out a fish. (SAF.)

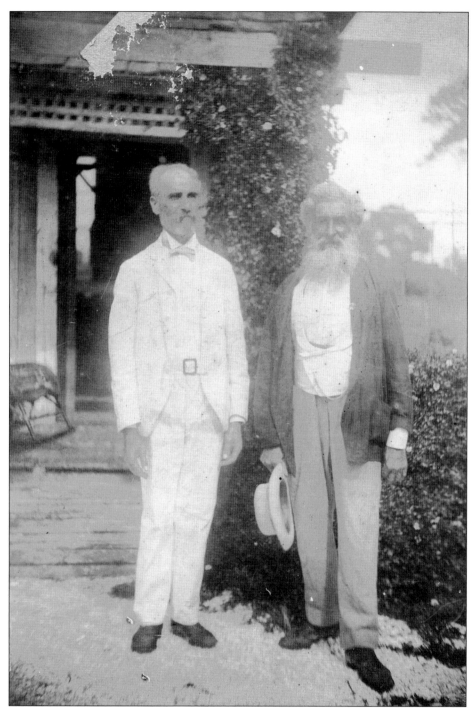

According to the Koreshan Unity membership list, "Jacob Horne arrived with the original pioneers from Chicago . . . He was a master craftsman in woodworking. He made the inlaid pegging board with which we played cribbage over the years." As a wood craftsman, Horne made good use of choice lumber from the Fort Myers Beach sawmill. In this c. 1900 image, Horne (right), age 76, is shown with Johann Englert in front of an unidentified building in the Estero Bay area. (KSHSA.)

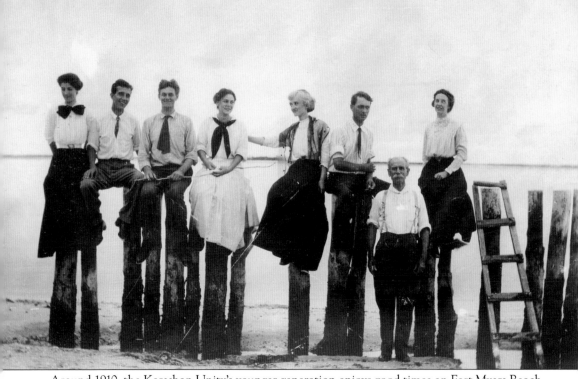

Around 1910, the Koreshan Unity's younger generation enjoys good times on Fort Myers Beach. Sitting on what was left of the sawmill pier at the south end of the island are, from left to right, Imogene Bubbet Rahn, Laurie Bubbet, William Hoyt, Ruth Boomer, Annie Ray Andrews, Claude Rahn, and Bertie May Boomer. One of the founding fathers of the Unity, James Bubbett, is standing in front of the group. (KSHSA.)

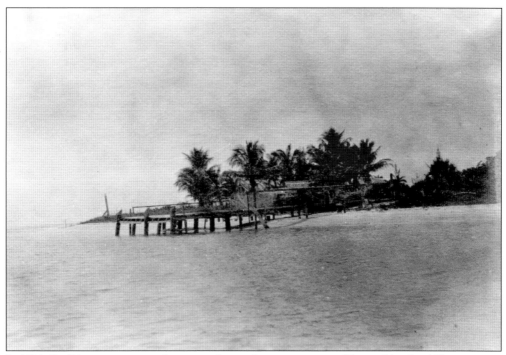

In 1893, Carl Briant, a squatter living on the southernmost point of Estero Island, sold his property to the Koreshan Unity for $20. In 1894, the Unity established a sawmill on the acquired property. Pine, mahogany, and other trees were brought to the mill from the island and the wooded areas around Estero Bay. Although the buildings are gone, this image shows the land and some of the pilings on which the sawmill and pier stood. (KSHSA.)

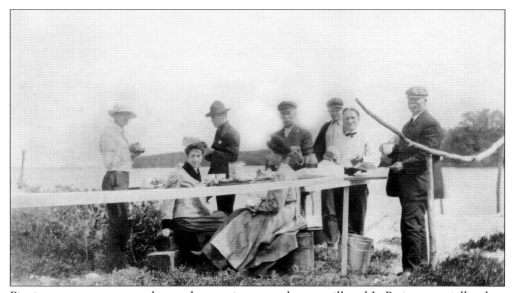

Picnics were common on the southern point, near the sawmill and LaParita, especially when guests visited the Koreshan settlement. Here, a group gathers around a set table. Dressed as they are, they probably were not planning on swimming or fishing! (KSHSA.)

In this c. 1915 photograph, a group of unidentified people sits in the sand on the gulf side of Fort Myers Beach. Hats, laced shoes, and ties were the fashion of the day. Sea oats stand in the dune behind the group. The Koreshan community lived in separate housing, with the men (called the "brothers") in one building and the women in another. Outings like this one, though rare, were enjoyed. (KSHSA.)

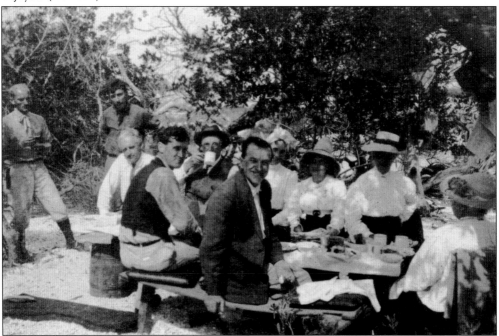

This photograph depicts another Koreshan picnic—this one on the bay side of the island, as identified by the buttonwood and scrub oaks behind the group. The women all wear hats, while the men are dressed more casually. Proper etiquette was paramount, as evidenced by the white napkins. (KSHSA.)

Children were seldom featured in Koreshan photographs, yet the community prided itself in providing only the best—including education—for the children. A 1922 *Flaming Sword* reported that "one great complaint of our public school system, heretofore, has been that of cramming the mentalities of pupils, oftentimes with studies of not much value to the students when their school careers were over. A third to a half of the school day is devoted to social work; nothing is omitted, pertaining to the child's welfare. Music, art, and science are important features. In music, for instance, the pupils are taught under a most competent teacher, cultivating a desire only for the best; anything bordering on the jazz is strictly tabooed." (KSHSA.)

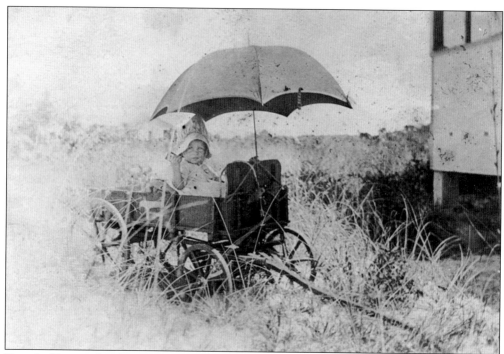

Dorothy Koester, daughter of Julius Koester of New Jersey and granddaughter of a one-time active member of the Unity, delights in sitting in this umbrella-topped toy wagon around 1910. During a vacation to Southwest Florida and the Koreshan settlement, the Koester family enjoyed an outing to Fort Myers Beach, where they stayed at the Koreshan beach house shown here. (FSHSA.)

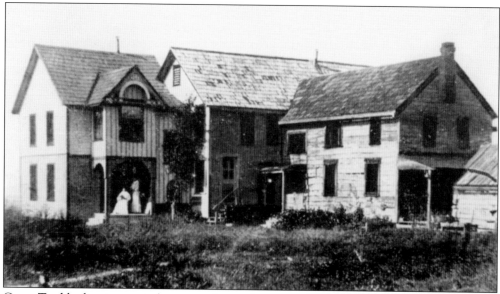

Cyrus Teed built a two-story home on the southernmost point of Fort Myers Beach, near the sawmill, a palm grove, and a tomb complex. He named the home "La Parita." Personal guests of Teed were treated to island hospitality in this, the most elaborate of the Koreshan Unity homes. (KSHSA.)

Shown holding Spanish bayonet limbs in 1910, these Koreshan farmers are pleased with their crop. It is not known what the farmers did with the plant, as it is inedible. (KSHSA.)

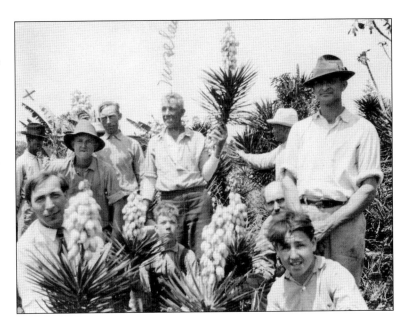

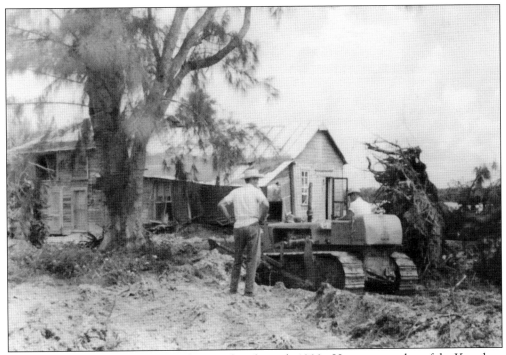

Gene Sanders built the island's first boatyard in the early 1900s. He was a member of the Koreshan Unity, but chose to live on Fort Myers Beach rather than at the Koreshan settlement on the mainland. After remaining in the family for three generations, the boatyard was sold in the 1970s. Following the sale, the Sanders Boat Yard was demolished, as shown here, to make way for Mid-Island Marina. (EIHS.)

Groves of coconuts, mangoes, and pineapple were planted on this property, providing guests with not only seaside views, but also tropical fruits at mealtime. Although not confirmed, the Koreshan house seen in these photographs is most likely the Rising Tide cottage as it appeared in 1908. Guests at the Rising Tide included inventor Thomas Edison. (KSHSA.)

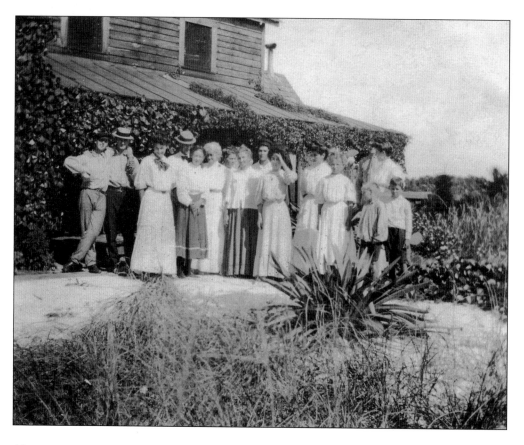

In 1894, Carl Luettich and his family moved from San Diego to join Teed's "utopia." Luettich's role in the community was to help provide food, so he became a fishing captain. Luettich's granddaughter Evelyn Horne, pictured here around age 80, told of a time when Luettich's sloop, the *Ada*, sank during an attempt to bring in a harvest of over 3,000 clams. Horne learned to cook from her mother, Dora, and Mound Key neighbor Mary "Grandma" Johnson. Later, she learned how to bake in the Koreshan bakery, and how to feed large crowds at the famous Koreshan fish fries on Fort Myers Beach. (KSHSA.)

Teed died in 1908 in a cottage on Fort Myers Beach. Upon his death, a concrete mausoleum was built at La Pirata Point, on the south end of the island, with a headstone inscribed: "Cyrus, Shepherd, Stone of Israel." The Koresh followers believed that Teed was immortal and would come back to life. To protect the tomb from vandals, Charles Luettich Sr. (father of Evelyn Horne) moved into a cottage on the property and served as one of the full-time guards of Teed's body. Thirteen years after Teed's death, the hurricane of October 23, 1921, brought destruction to the sacred site. According to Luettich's report, "The waves piled up until we had to flee for our lives, barely making our way to safety. At dawn, only the headstone remained." Disillusioned followers lost faith and began an exodus from the settlement. In the 1909 image below, loyal Koresh followers gather around the tomb of their leader. Pictured are, from left to right, Virginia Andrews, Christine Hamilton, Ester Stottler (standing), Evelyn Bubbett (seated) James H. Bubbett, Elizabeth Robinson, Etta Silverfriend, George W. Hunt, and Bertha Boomer. (KSHSA.)

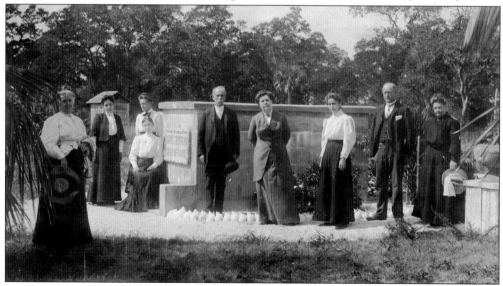

Four

CRESCENT BEACH

Compared to its later appearance, Fort Myers Beach—then called Crescent Beach—looked all but deserted in 1920. The 1921 completion of the wooden bridge marked the end of reliance on water transportation and the beginning of roads and bridges that connected the island with the mainland. Rolfe Schell described the bridge: "It was a lift type bridge instead of a swing bridge . . . I recall there was a bridge-tender's house at the span . . . and he had a supply of bait for those who wanted to fish from the bridge."

"Sea oats and sandspurs. Shells and powdery sugar sand. And, of course, the warm green water of the Gulf of Mexico. That's just about all there was to Fort Myers Beach when I was growing up in the 1920s," shared Nell Weidenbach. "There wasn't even a decent access road—just the oyster-shelled McGregor Boulevard with fiddler crabs scurrying in every direction and a briny smell assaulting our noses long before the beach was in sight."

No longer dependent on the constrictive schedules of public transportation, the first bridge provided a welcome sense of independence to the islanders. The island's good life attracted both visitors and residents and the bridge provided the means to attain it. The wide, hard-sand beach drew weekend crowds showing off their pricey automobiles and latest beach-going fashions. Since Lee County was pretty much wide open concerning gambling, restaurants and casinos featuring one-arm bandits and gaming tables were built to tempt the new island clientele. In 1921, contracts were let for a 500-foot pleasure pier in the gulf in front of the Phillips Casino, and Jack Delysle built the Seminole Sands Casino and Hotel. It was during this time of newly discovered freedom that Fort Myers Beach adopted what became known as "island time."

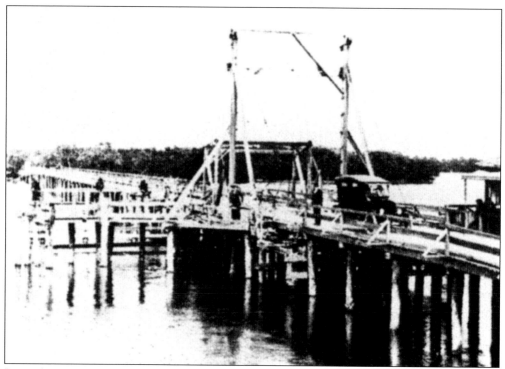

In an August 1921 Current Events in Our Community Life column in the Koreshan weekly newspaper *The Flaming Sword*, D.J. Richards wrote: "Estero has become the wonder place of Lee County since it has been connected to the mainland by a bridge across Matanzas Pass. The island shore is formed like a crescent and is now known as Crescent Beach, and by all odds the most attractive of any in the state." The first bridge connecting Fort Myers Beach to the mainland opened on May 6, 1921. Drivers were charged a 50¢ toll, plus a 4¢ war tax, for vehicles carrying up to five passengers, plus an extra 10¢ for each extra person. After only five years of service, a 1926 hurricane washed the wooden bridge away. The first bridge is pictured here before being replaced with a swing bridge in 1926, also pictured. (KSHSA.)

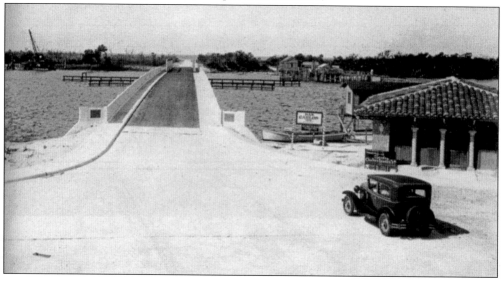

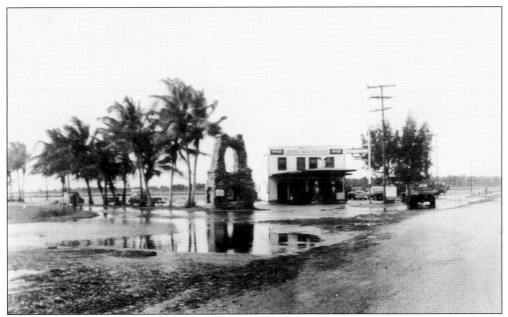

Barrett's Store, located on J.T. Barrett's 200-acre farm, is pictured here as it appeared in the 1920s. Barrett said, "Traditional commercial undertaking, though it lacked glitter, was responsible for much of the road building and land clearing that opened up Fort Myers and southern Lee County (including Fort Myers Beach), allowing it to develop into a major tourist and business destination." (SWFHS.)

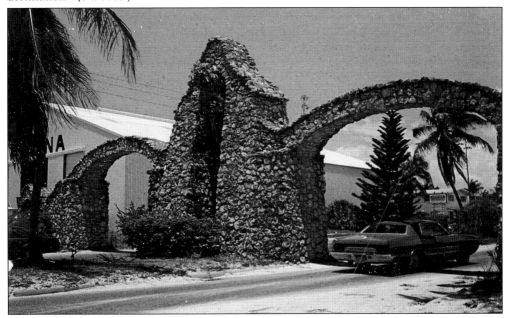

These coquina shell and rock arches were built near the toll bridge by developer Tom Phillips in 1925. Phillips was developing San Carlos on the Gulf, which, at the time, was still part of the mainland. During the 1926 hurricane, the isthmus of land connecting San Carlos to the mainland was washed away and San Carlos became an island. Years later, in 1979, the arches were taken down to make way for the Sky Bridge. (EIHS.)

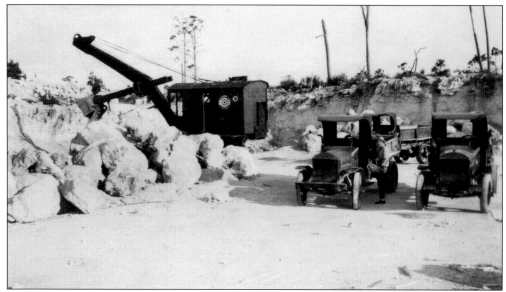

Along with the Fort Myers Beach swing bridge came a steady line of automobiles, necessitating the replacement of the sand and shell roads. Previously, island developers turned to the Calusa shell mounds, quarrying the centuries-old shells to be used as road material. Not only did the shells provide a hard surface, but also superior drainage. Here, shell is quarried at an unidentified Calusa mound in the 1920s. (KSHSA.)

The only concrete road at Fort Myers Beach was constructed in 1927. It started just north of the arch and ran to the county pier. The road was referred to in the 1965 book A *Short History of Fort Myers Beach* by Barrett and M. Adelaide Brown: "This bit of paving is now thirty-five years old and in just as good condition as when first constructed. It makes one pause and wonder if the 'economy' of constructing our usual black-top road is far outweighed by the expense of repairing and rebuilding them." (EIHS.)

This Hupmobile roadster sits on the beach in the 1920s. The three men pictured are Harrison Fuller (left), co-owner of *Tropical News*; Tommy Gavin, advertising manager (center); and an unidentified man. Sable palm trees, commonly called cabbage palms, are visible in the background. Early settlers used the heart of this palm to make swamp cabbage, a tasty southern delicacy of slow-cooked palm cabbage seasoned with ham. (SWFHS.)

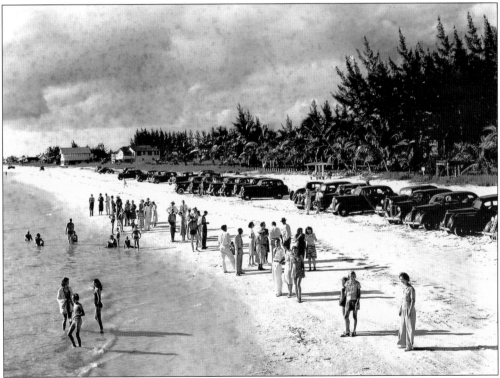

After the completion of the toll bridge, cars shared the beach with sunbathers, swimmers, and fishermen, as pictured here in the 1930s. A.J. Bassett recalled, "My mother almost lost both of her twin daughters the summer we were seven. My sister Connie nearly drowned and I got hit by a car speeding down the beach as I stepped off the pier steps. I learned to watch out for those crazy drivers!" This 1930s photograph was taken from the pier, looking north along the beach. (EIHS.)

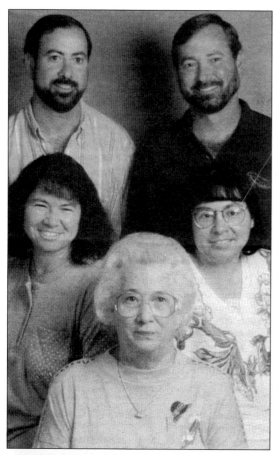

In an interview by Jill Tyrer appearing in the November/December 2002 issue of the *Times of the Islands*, Blanche Santini Townley Lee shared, "I was born in 1929 on a lighter [houseboat] moored behind the island's only grocery store in the first canal on Fort Myers Beach. It was a primitive land back then. We moved into the house Daddy [Cyril Santini] built in 1936." Blanche Santini is pictured at left shortly before her death in 2010 with her children, clockwise from lower left, Carla Middleton, Jay Townley, Mark Townley, and Marci Hallock. Below, Blanche is pictured as a child around 1937 behind their home on Primo Drive. (EIHS.)

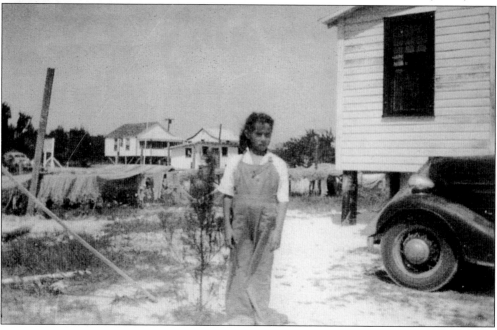

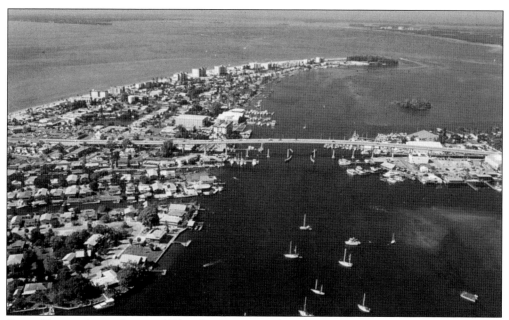

Some 50 years later, the canal Blanche Santini spoke of is visible in this 1990s aerial view of San Carlos Island (at right), the Sky Bridge, and Estero Island (at left). The first canal below the Estero Island side of the bridge is where the Santini home was located. Also visible are the Sanibel Causeway and Sanibel Harbor Resort (upper right) and Sanibel Island (upper left). (EIHS.)

The first pier on Fort Myers Beach was located behind the Winkler Hotel, which was at the end of the road. Motorists had to make a U-turn at the hotel to return north from the pier. George Stansbury recalled: "We spent an awful lot of time on the pier. Fishing was good. You could while away hours fishing or just watching fishing. A lot of action!" Francis Santini remembered watching the sunsets from the pier with her friends. (EIHS.)

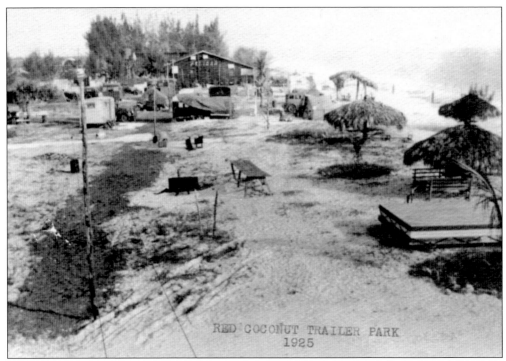

RED COCONUT TRAILER PARK
1925

The Red Coconut Trailer Park, built in 1925, became a beach landmark for snowbirds, summer vacationers, and families with servicemen stationed at one of Lee County's military bases. Ted Beard recalled memories of the park in the 1960s: "I remember Speedy, the driver of my school bus, #49, parking out in front of the park at Thompson's Grocery. While she waited for her last run, she'd get a Delaware Punch or a Frostie to pass the time." The Australian pines in the background of both images spread to the rest of the park by the 1960s, providing shade; however, the tiny, round, spiked pinecones forced campers to develop tough soles or wear shoes. (EIHS.)

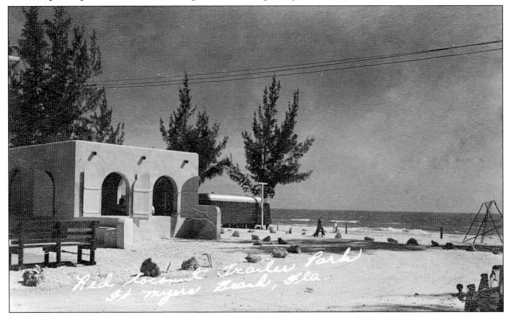

Red Coconut Trailer Park
Ft. Myers Beach, Fla.

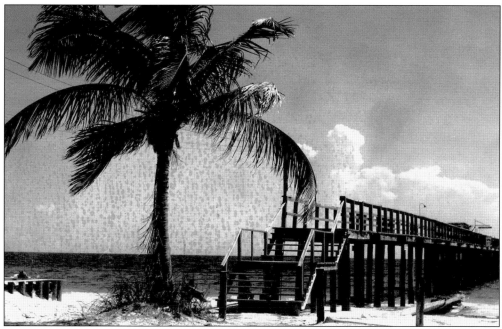

The pier is pictured here in the 1930s. In an interview in Jean Gottlieb's *Coconuts and Coquinas: Island Life on Fort Myers Beach, 1920-1970*, Emily Foster recalled that "in the summertime there weren't many people here, and after supper everybody would gather on the pier to either fish or visit until dark. When dark came, the mosquitoes drove you in and you went on home, you were tired, you had a full day, and you went to bed and got ready for the next day." (EIHS.)

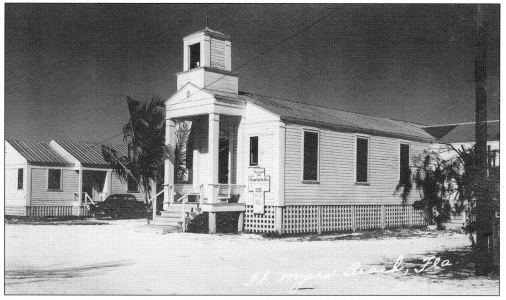

Dr. William C. Kennedy, pastor of the First Presbyterian Church in Fort Myers, started the first mission on Fort Myers Beach. The group first met in Ann Pulcifer's living room, then at the pavilion at the Red Coconut Trailer Park. Ella Neems donated land and Ulrich Eberhardt constructed the building for The Chapel by the Sea, pictured here in the 1950s. The church held its first service in April 1938. (EIHS.)

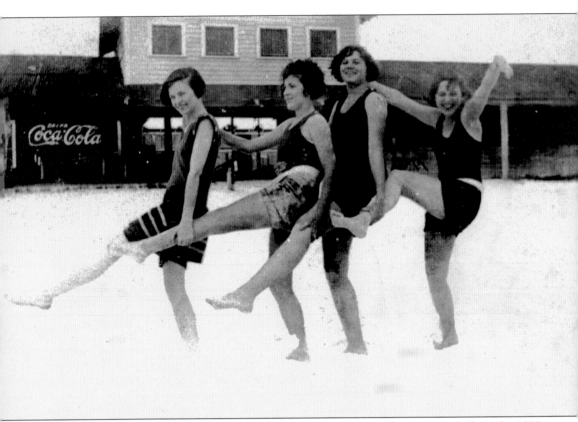

The surf and fresh air brings out the giggles in these girls posing for a photograph in the 1920s. The Coca-Cola sign was on the side of a building near Nettie's. Into the 1960s, the beach was a favorite destination for Fort Myers High School students skipping class. "I remember skipping school—the only time I ever did it, mind you—and we went to Fort Myers Beach and I got so sunburned I was miserable! Maybe I had it coming," said LaDonna Peterson, former Fort Myers resident. (SWFHS.)

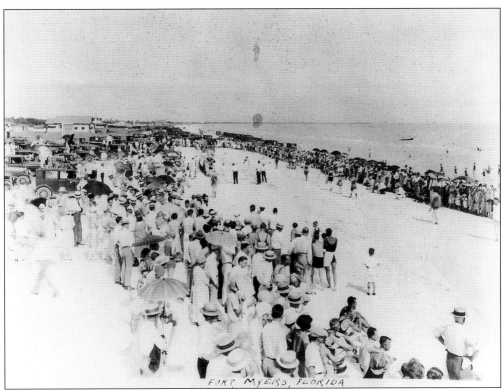

An annual "summer schedule" began in the 1920s. Nell Weidenbach recalled, "Fort Myers businesses closed down every Thursday afternoon and a parade of local residents in their Model Ts and Overlands, with an occasional Hudson or Studebaker, chugged along the 18-mile unpaved road leading to Crescent Beach. The cars struggled through the soft sand to park side by side just above the high-tide mark." (SAF.)

The tiny black specks in this aerial view are actually cars parked along the stretch of beach near the Beach Hotel. Estero Boulevard is visible near the top of the image. The Winkler Pier stretches out into the Gulf of Mexico. In the 1920s, fishermen, sunbathers, and day-trippers all enjoyed congregating at the base of the pier. (SAF.)

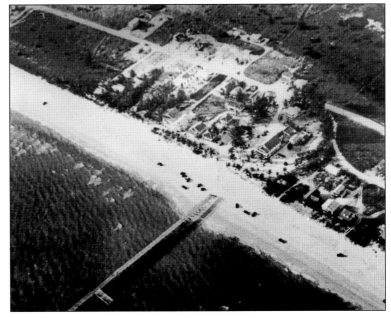

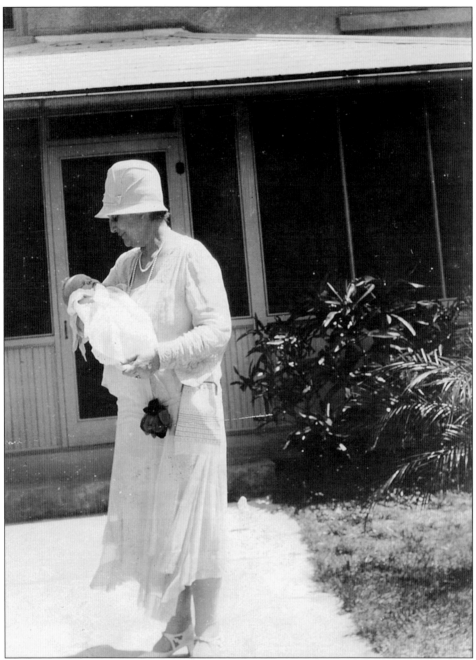

Dr. Robley Newton and his wife, Jane, owners of the Beach Hotel, developed a special friendship with Thomas and Mina Edison. Mina Geddes Creech, daughter of Robley and Jan Newton and namesake goddaughter of Mina Edison, stated that "Mrs. Edison was a great pal of my grandmother. They used to play golf together in Fort Myers. She would bring me a little present and stay for the afternoon." Mina Edison is pictured here in 1930 with Mina Jane in her arms. Mina Edison was also a favorite with all the island children. The Beach School dedicated its 1939 annual to her: "The pupils of The Beach School wish to dedicate their second annual to Mrs. Thomas A. Edison, who was so thoughtful to us when we visited her estate." (Geddes collection.)

In an interview conducted by Jack and Martha Remington in February 1990, Evelyn Horne reminisced: "Thomas Edison would come to my father's house on Sunday afternoons and visit. I remember one Christmas we drove in there to Fort Myers for a special orchestra concert at the City Hall. We parked our Ford Touring car and then I saw there was a lighted Christmas tree! I think I was about ten years old and the tree looked huge and tall, maybe 50 feet high! We sat on little folding chairs at the base of this big, beautiful lighted Christmas tree and Thomas Edison gave each child a little gift. Oh, and Henry Ford gave each child a shiny new dime! That was a dream of a lifetime for a child!" (Geddes collection.)

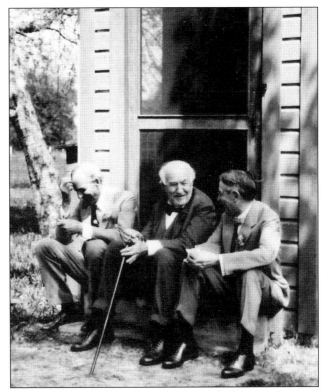

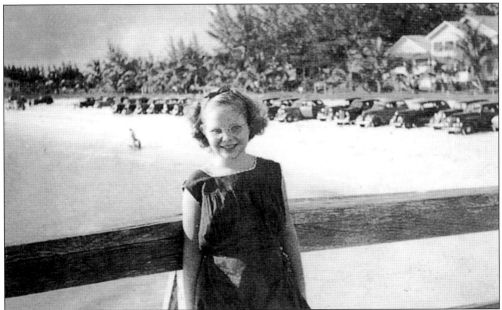

Mina Creech Geddes stands on the Winkler Pier in 1939, with cars parked on the beach behind her. She lived with her family in the Beach Hotel complex located to her right (not pictured). In an interview with the author, Geddes's friend A.J. Bassett said, "Above the tide line the shells were piled so deep that they were actually ankle-deep! Connie and I would fill buckets with shells and then our mom would take us to Bonita Beach to the shell store to sell them." (Geddes collection.)

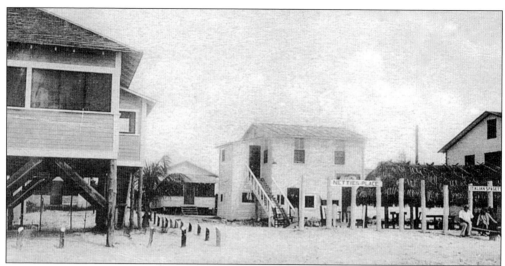

"Standing directly on the gulf, shellers, bathers, and beachcombers stopped barefooted and bathing suited for a bit of Italian food and a cold beer at Nettie's, the first restaurant directly on the gulf," recalled Rolfe Schell about Nettie's Restaurant, shown here in the late 1920s. In *History of Fort Myers Beach*, Schell went on to say, "The site of the building was on land owned by the 'five Pavese brothers' each of whom had a small cottage business in a cluster of buildings [shown above]. Rocco Pavese operated a barbershop in Fort Myers, but on Sundays he offered his services to early island residents who believed in the slogan, 'save a trip to town.'" (EIHS.)

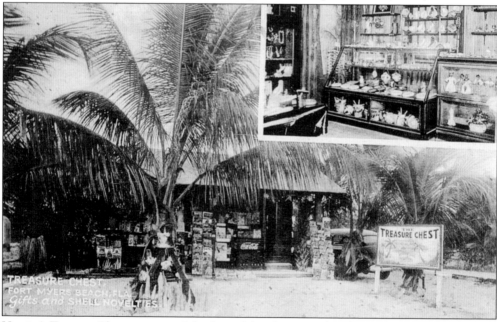

Harriet's Treasure Chest was one of the first of the ubiquitous beach tourist shops that came to line Estero Boulevard. Other businesses on the boulevard included Johnson's Beach Drug and Fountain Service, selling ice cream sodas and milkshakes for a dime, the Red Front Grocery Store, and the Beach Cinema. Of the theater, Schell explained, "As I recall, the admission was 15 cents and popcorn was a nickel. The theatre had benches in the front for the children and balcony for the colored." (EIHS.)

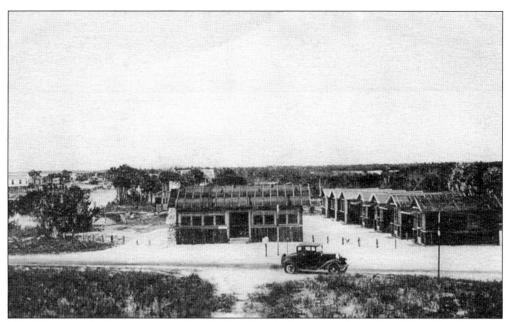

The Silver Sands Cottages, owned by the Lea family, have served as a Fort Myers Beach retreat destination since the 1930s. All accommodation owners were caught in the rent freeze of 1942 and summer rates were in effect all year round. Although this was a hardship during the winter months, it was offset somewhat by the fact that there were no vacancies in the off-season. The cottages are shown here in 1935. (EIHS.)

Harry Steel erected this building, constructed from concrete and coquina shells, in the late 1930s. From 1941 to 1945, it was a hamburger joint and general meeting place for the "war widows" whose husbands were stationed at Page and Buckingham Fields. Later, the building housed a grocery store, a photograph shop, a bakery, the post office, and the Cotton Shop. (EIHS.)

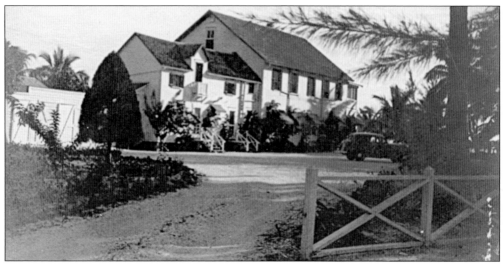

In an interview recorded for the WGCU documentary *Untold Stories: Fort Myers Beach*, George Stansbury recalled, "Now, the Beach Hotel [pictured] was an icon—known as a place of comfort. People would come year after year. Charles Lindbergh and his wife, Anne, were well known to the Newtons, owners of the hotel. As kids, we would hang on the fence out front to get a glimpse of the famous people!" (Geddes collection.)

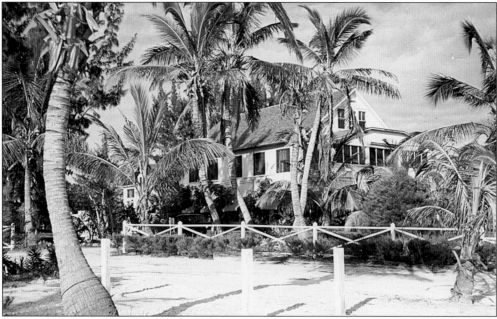

Jane Newton, wife of Dr. Robley Newton and co-owner of the Beach Hotel, provided most of the entertainment for hotel guests in the 1930s and 1940s. "One evening, Jane announced to the full dining room that everyone was invited to meet a special guest in the hotel lobby at 8:00," recalled Robley Geddes Greilick, Newton's granddaughter. "Curious guests watched as a strange car pulled up at exactly 8:00 and Eleanor Roosevelt, our First Lady, was helped out by her chauffer. Mrs. Roosevelt was greeted with applause as she entered the lobby. Then, Eleanor began to chat informally. It took several minutes for the guests to realize that it was really Jane! Those were good times." (Geddes collection.)

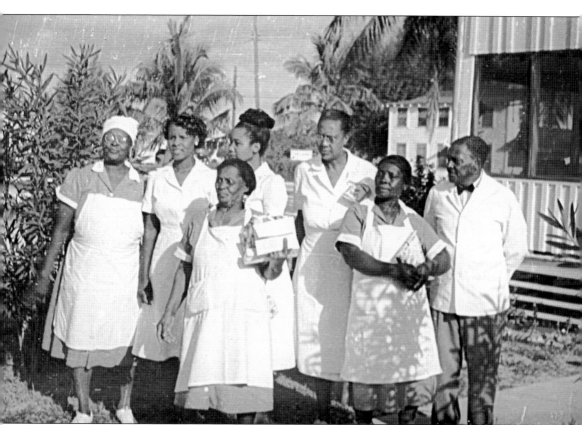

Of the Beach Hotel staff, Robley Geddes Greilick recalled, "Grandfather [Doctor Robley Newton] would go to Safety Hill in Fort Myers to find people to hire. During the lynching times no blacks were on the beach after dark. It was a different time then." Geddes continued, "The hotel hired staff for the season, which ran Thanksgiving through Easter. We mostly had people from Miami in the summer months. The hotel's staff lived on the beach in hotel housing through the week. The cook had a separate room and the rest stayed in staff quarters like dorm rooms. Sunday, after the main noon meal the staff got to go to their homes in Fort Myers, but they were back in time to cook Monday morning breakfast for the guests or begin cleaning the guest rooms." The Beach Hotel staff is shown in this 1949 photograph. (Geddes collection.)

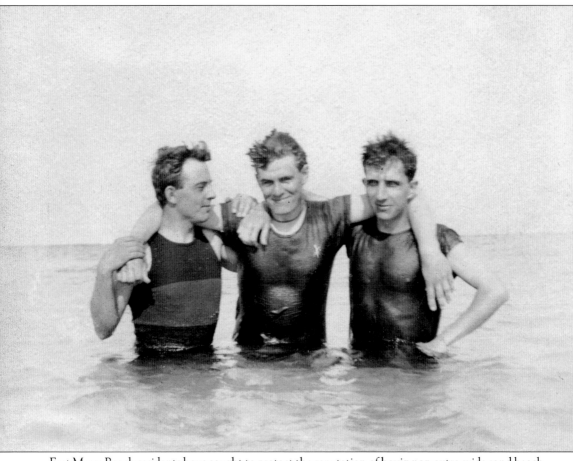

Fort Myers Beach residents have sought to protect the reputation of having an extra-wide sand beach with a gentle slope and no undertow, which led to the community proclaiming Fort Myers Beach as the world's safest. Due to erosion, the beach loses sand each year, necessitating renourishment. In 2011, the renourishment project cost $4 million and replaced sand for approximately 1.2 miles (420,752 cubic yards). In this 1915 image, three unidentified young men enjoy the World's Safest Beach. (KSHSA.)

Five

TOURISM

By the end of the 1930s, Fort Myers Beach was known as a place that fostered a safe, relaxing lifestyle. Then, suddenly, changes began to arrive. Following the bombing of Pearl Harbor in December 1941, World War II came to Lee County. During the war, thousands of gunners were trained at page Field (officially named the Fort Myers Army Air Field), while Buckingham Army Air Field trained some 50,000 fighter pilots. Soon, there were more military members than civilians in Lee County. The "crash boats" of the Coast Guard, stationed at Snug Harbor, brought the reality of the war to Fort Myers Beach. A checkpoint, manned by guards in mosquito gear, was established near the swing bridge, and everyone was stopped as they traveled to and from the island. Aware of the danger of German submarines lurking offshore, soldiers knocked on doors at night to alert residents if lights were showing through blackout curtains. Each weekend, public transportation delivered busloads of weary soldiers looking for a little peace and solitude. Jenk's Place, the bowling alley, and the Commodore Hotel were popular hangouts for the soldiers.

Upon finding a paradise called Fort Myers Beach, it is no surprise that many soldiers relocated their families to the beach during training, while other servicemen returned as tourists or permanent residents upon discharge at the end of the war. As word of the unspoiled beach life spread, businesses proliferated, "baby boomers" outgrew the original cottage school, and tourists arrived by the thousands.

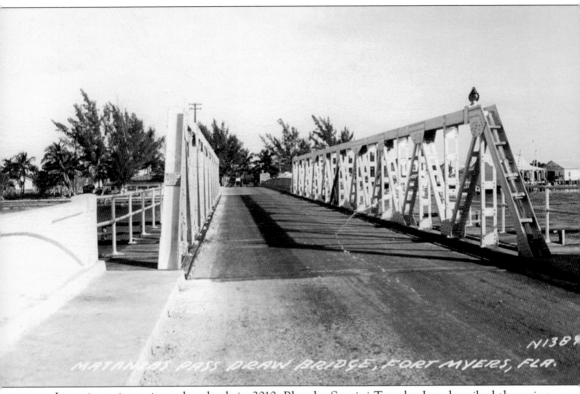

MATANZAS PASS DRAW BRIDGE, FORT MYERS, FLA. N1389

In an interview prior to her death in 2010, Blanche Santini Townley Lee described the swing bridge: "We used to get a thrill out of riding the school bus and getting to open the swing bridge. It was operated by the tender—or a busload of schoolchildren—standing in the center of the span. They inserted a large pole vertically into the contraption and a crossbar at the top of the 'giant key' allowed them to crank open the bridge, which rotated open horizontally." Marci Hallock Chester added, "I went to sleep every night looking at that thing . . . and listening to the cars . . . thump, thump, thump, cross that wooden bridge . . . sometimes thump, thump, thump . . . splash—not good!" This was actually a used bridge purchased from an East Coast community in 1928, but it served motorists well (except when it got stuck in the open position) until the Sky Bridge replaced it in 1979. (EIHS.)

Construction of a road connecting the east and west coasts of southwest Florida began in 1916. By 1923, there had been little progress. In that year, Barron Collier offered to finance the project, with the agreement that the road go through Collier County. It was with renewed enthusiasm for the project that a group of men calling themselves the "Tamiami Trail Blazers" set out on a promotional expedition through the swamps. Driving a variety of Model T Fords, a supply truck, and a brand new Elcar, they completed their trek in 26 days. The Tamiami Trail officially opened in 1928, providing a convenient connection between Southwest Florida, including Fort Myers Beach, and Florida's east coast. Here, members of the expedition are pictured in 1923. (KSHSA.)

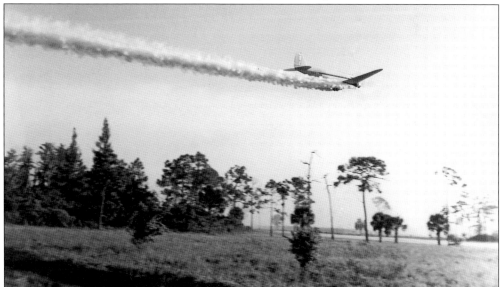

In *Coconuts and Coquinas*, Jean Gottlieb observed, "The island may have seemed like heaven, but the mosquitoes reminded you that you were still on earth. Smudge pots, citronella, and straight DDT were common combatants in earlier times. Then, in 1946, Murray Thwaites and Jeff Brame raised enough money to begin a spraying and fogging program on the island. This was the beginning of Lee County's mosquito control. In this 1949 image, a mosquito control plane fogs repellent. (EIHS.)

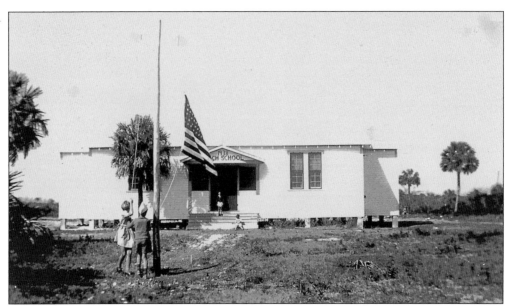

In 1937, a group of mothers established the first school in the Mayhew-Page Cottage. Lee County furnished a desk and paid Lois Alexander a monthly salary of $80. Within a year, the school had outgrown the cottage and a larger one was built (above), with two rooms rather than one. In a 2003 interview for the WGCU documentary *Untold Stories: Fort Myers Beach*, Henry Blakely reminisced about his beach school days in the cottage school: "One morning while I was waiting for the school bus, my teacher Lois Alexander went by in her little black Model-A Ford Coupe on her way to school. Well, I never got there on the bus, so she came back and got me—and I was just about to get in my boat to go fishing—yes, she caught me and took me back and put me in school." In 1949, the present school building, shown below, was built. (Both EIHS.)

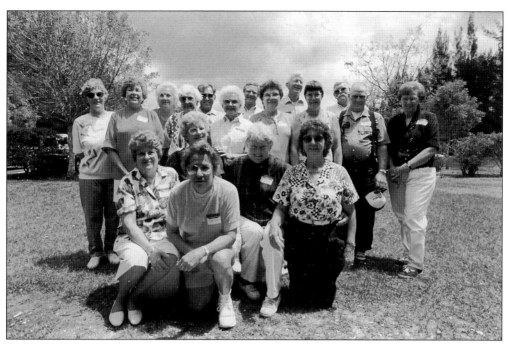

At the 50th Beach School Reunion of all grades (1–6) held at Lakes Park in Fort Myers on April 11, 1992, the former students joined two former teachers for a time of reminiscing. From left to right are (kneeling) Mina Kingston Tinsley, A.J. Bassett, Connie Bassett Amos, Laverne Y. Arnold, and Frances Santini; (standing) Joyce Thompson, Josephine K. Hughes, Blanche Santini Lee, teacher Lois Alexander Congdon, Henry Blackely, teacher Edythe Shawcross, George Stansbury, Mina Jane Geddes Creech, Frandy Bassett, Jean Wilkison Sunman, Oscar McCenithan, Harold Sunman Jr., and Betty Reese McHorter.

Mildred Bassett taught at the Beach School and Beach Elementary. This picture was taken in 1943, when she was the principal at Beach Elementary. As told by Bassett's daughter A.J., "My mother also drove the school bus. She'd get up early, pick up the children, teach, and then drop the children off after school. When the servicemen were here they would get on the empty bus and just wait until my mother would start it up to go. They didn't care where she was heading; they just wanted to take a ride on the beach." (EIHS.)

On October 17, 1947, dozens of beach homes were twisted from their foundations, docks were smashed, and boats were lost as a hurricane struck Fort Myers Beach. Flooding is evident in this image of three unidentified military trainees who found refuge at Nick and Gertie Santini's rental cottages on Pearl Street. This photograph was taken the morning after the hurricane made landfall. (Santini collection.)

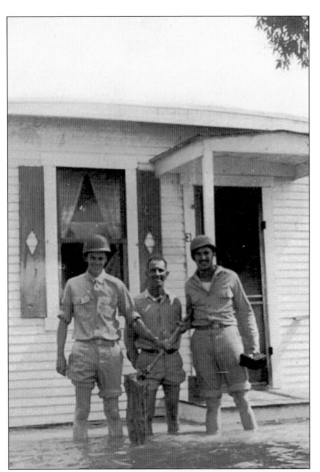

This 1943 photograph shows a group of Civil Defense volunteers serving Lee County during World War II. One of the group's responsibilities was going to the Fort Myers bus station to meet the wives of soldiers in training and finding them a place to spend the night and get settled before meeting their husbands. Pictured here are, from left to right, unidentified, Marie Jones, Billie Zimmerman, two unidentified, Thelma Moody, Hortense Sapp McConnell, and Mary Geddes. (Geddes collection.)

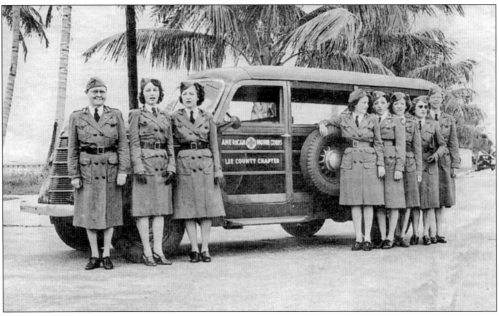

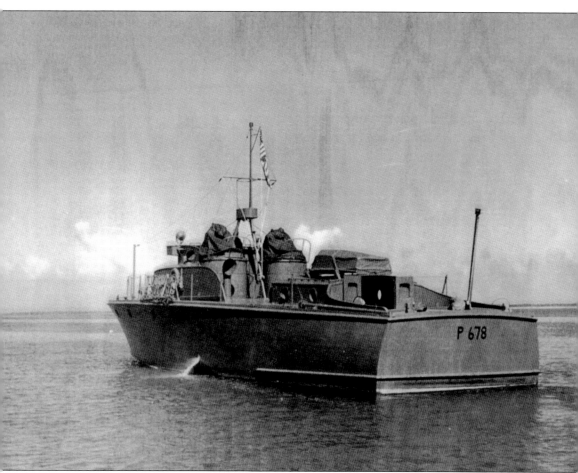

During the war, the Coast Guard stationed a crash boat at Snug Harbor on Fort Myers Beach to rescue pilots whose aircraft went down in the gulf during routine training. To contrast their unhappy duties, crews painted humorous cartoons on their rescue boats. A.J. Bassett recalled that, when she was a child, "many times while we were playing on the beach we had to duck because the planes came in so low they actually clipped the trees in McPhee Park." In Jean Gottlieb's book, Art Reckwerdt said: "You'd hear a sound like depth bombs but they were no more than 50-gallon drums. We saw a lot of dead fish wash up." With German submarines prowling off of Fort Myers Beach, residents were required to have blackout curtains. Even car headlights had the top half painted black to reduce the illumination. This picture shows the crash boat stationed at Fort Myers Beach from 1941 to 1945. (EIHS.)

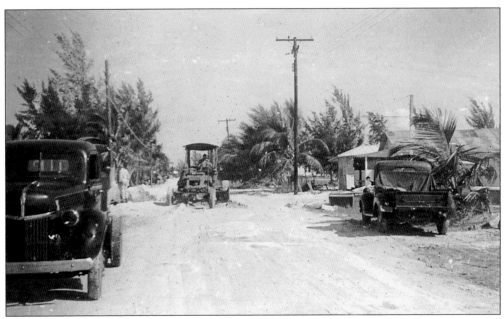

As a low-lying island, Fort Myers Beach is vulnerable to hurricanes. In an interview conducted by Koreshan State Historic Site volunteers, Evelyn Horne remembered the hurricane of 1926: "We weathered the hurricane and the house blew off the foundation. We were in a brand new Model T 1926 Touring Ford. We finished that hurricane in that Ford and we went right through the pine woods! My friend Roy Lamoreaux weathered the hurricane in the top of a coconut tree!" The hurricane of 1944 was another terror. A.J. Bassett recalled, "It was three days before people could get back on the island—unless you could find a place to dock a boat—because the swing bridge had blown open and would not close." Above, a road plow has piled up sand to the left, just as northern plows pile snow after a blizzard. Seen below are homes lifted from their foundations during the hurricane of 1944. (Above, Geddes Collection; below, EIHS.)

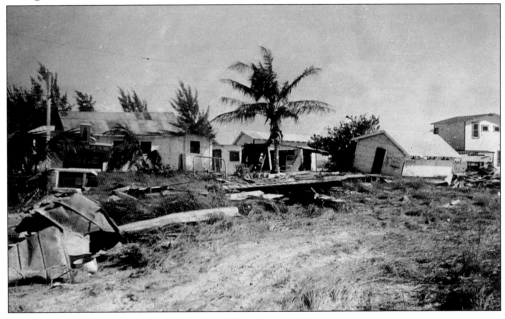

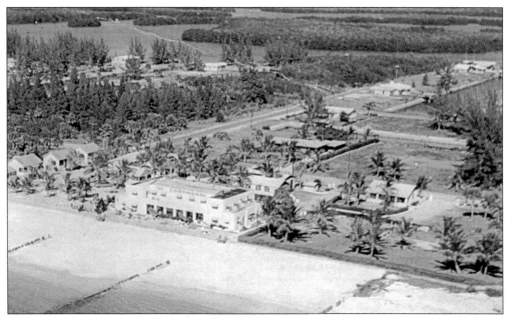

The Commodore Hotel, built in 1944, had an outside dance floor on the beach, making it a favorite place for soldiers stationed at Fort Myers to relax. On Sundays, soldiers from Page Field or Buckingham Air Base arrived at the beach by the busload. A.J. Bassett recalled how as young girls, she and her twin, Connie, ran a makeshift bathhouse for the men by storing the soldier's clothing and effects in handled brown paper bags on shelves; they would give the soldiers a claim ticket with a corresponding bag number. Bassett's mother ran a concession stand, selling hot dogs and beer, while her brother, Frandy, earned spending money by collecting empty beer bottles and redeeming them for two cents each. Following World War II, Fort Myers Beach began getting returnees—soldiers who had spent time on the beach during the war. They had seen paradise and chose Fort Myers Beach as a permanent home or a favorite vacation spot. These two postcards show the Commodore Hotel, owned by Cyril Shawcross and his wife. (EIHS.)

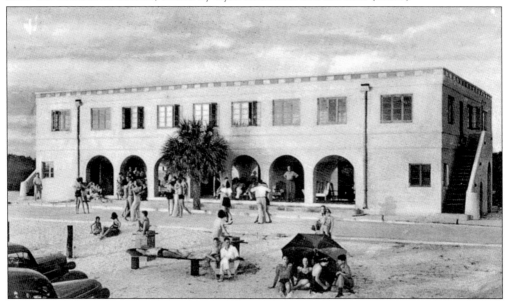

The Fort Myers Beach Library has been a community project from its beginning. On September 25, 1955, the first library opened to the public. The building, shown here, was so small that if more than five people entered simultaneously, librarian Marge Quigg had to step outside so the patrons could browse the 1,200 books. (EIHS.)

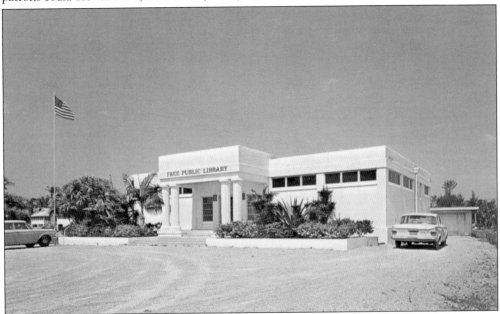

Erected, administered, and maintained by a volunteer staff and private gifts, the second library opened in September 1961 on Bay Street. In 1970, the library pictured here doubled in size, and the current building was complete in 1994. Jayne Coles, library director for 25 years (from 1975 to 2000), became the library's first paid employee in 1972. In 2011, the library began yet another major expansion project. (EIHS.)

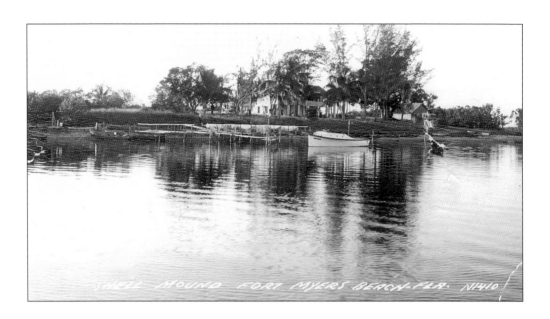

From 1909 when Harold and Milia Case completed the building of their brick home, until the late 1940s, the Mound House property changed hands many times and doubled in size. After remodeling the structure, a group of scientists established the Shell Mound Experimental Station on the property in 1947. Experimenting with food preservation techniques, the scientists are credited with the discovery of the process for freezing concentrated orange juice. In the photograph above, the Mound House, located on Estero Bay, is seen as it appeared when Captain Jack DeLysle purchased it 1921. Seen below is the Mound House as it appeared after DeLysle added a second story to the home, but before it became an experimental station. (EIHS.)

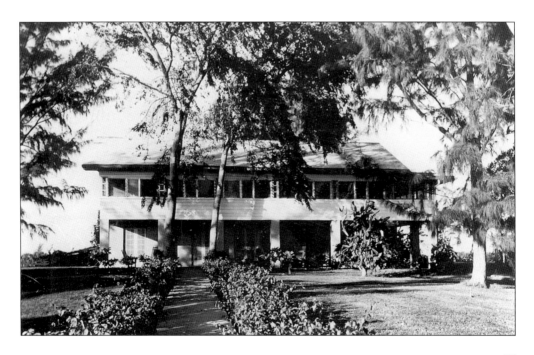

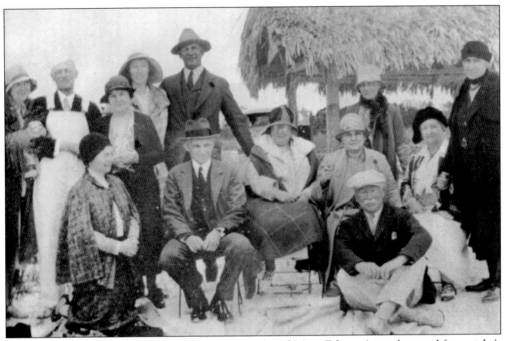

Island visitors included Henry Ford (seated, center) and Mina Edison (seated second from right). Recognizable behind Ford (standing) were Mona Burroughs Wandrack and her husband, Joseph Wandrack. A Seminole chickee shelter stands in the background. (FMHM.)

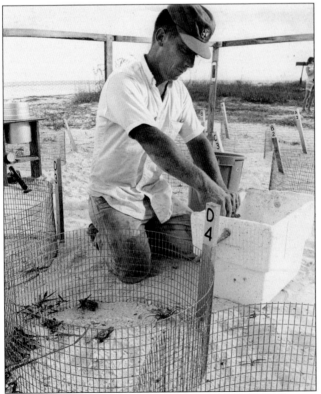

Loggerhead turtles have long been considered the darlings of Southwest Florida's beaches. The Florida turtle-nesting season runs from May 1 through October 31. Once hatched, the young naturally crawl toward lights, often not making it to the gulf waters. Experts estimate that only one hatchling in 1,000 reaches adulthood. Although this method was later found to be ineffective, this image shows a 1940s resident making a turtle corral in hopes of protecting the scrappy hatchlings. Fort Myers Beach residents have long made turtle protection a community mission. (EIHS.)

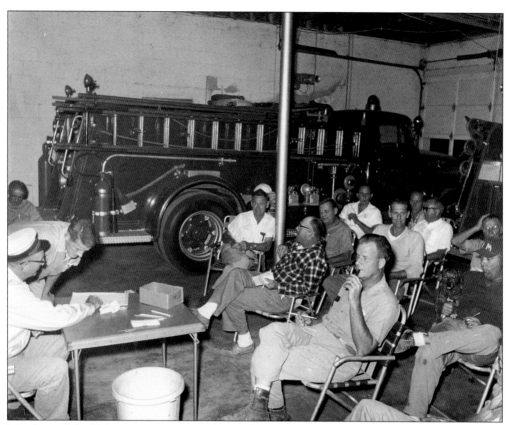

Members of the Volunteer Rescue Squad attend a meeting in the old firehouse in the 1950s. The squad's equipment consisted of the surplus truck (shown here), a jeep with a hose and pump, and many volunteers. In September 1963, the squad dissolved and became part of the tax district through the Enabling Act. (EIHS.)

The Tarpon Hunters Club of Fort Myers Beach held an annual Gopher Turtle race in conjunction with Beach Day. Turtle entries were elaborately costumed and enthusiasm was high. February 1964 saw a record 53 entries. In this image, a crowd assembles around the competing turtles. After the race, the turtles were retired and returned to the wild. (EIHS.)

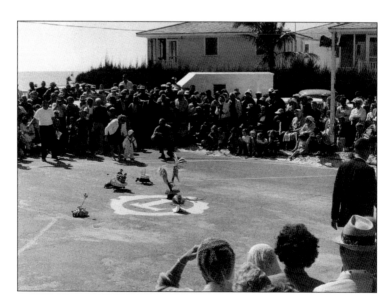

Thousands of family picnics and carefree vacation days were cherished in the Fort Myers Beach Public Park. In written correspondence with Marci Hallock, Ethel Helveston Travis recalled: "The park had picnic tables—we used to have so much fun there as children!" Marci Hallock added, "Ditto!" (EIHS.)

An unidentified woman and child enjoy the pure white sand of Fort Myers Beach in the 1950s. The people standing on the pier in the background are watching the Beach Day Parade at the end of San Carlos Boulevard. (EIHS.)

Santa arrived by boat for Christmas on Fort Myers Beach, as shown in this 1951 image. To the delight of the children, Santa landed at the county park and was sponsored by the Fort Myers Beach Women's Club. "As kids we were thrilled when we saw Santa coming in a decorated boat. We all laugh as we remember the year Santa was drunk and fell into the water while getting out of the boat," recalled Robley Geddes Greilick. (EIHS.)

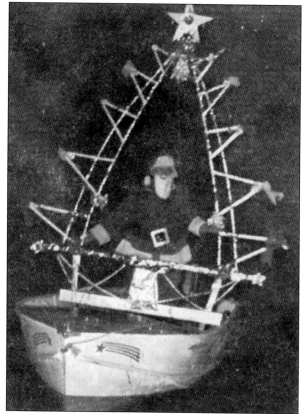

The Fort Myers Beach Community Hall was the site for weekly dances held each Monday for the island's youth. The preteens and teens of the 1950s appear to be having a good time. (EIHS.)

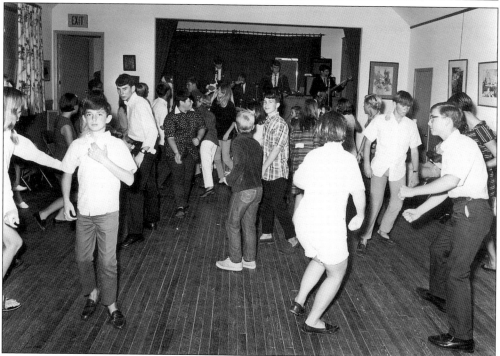

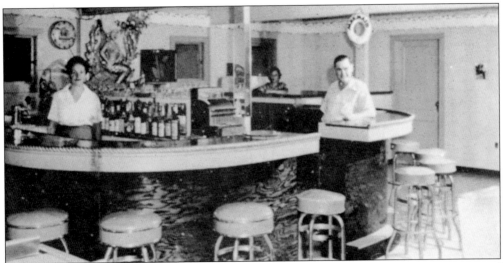

Stories are told at the Surf Club, an old Ft Myers Beach watering hole where generations of revelers have swapped tales of love lost and hurricane near-misses. The Surf Club, built in 1938, originally on Gulf Front as Nettie's Spaghetti, was converted into a bar in 1953. The Cottages, a bar, and the Mermaid Club on Fort Myers Beach were originally built as a gambling casino, restaurant, and bathhouse. (EIHS.)

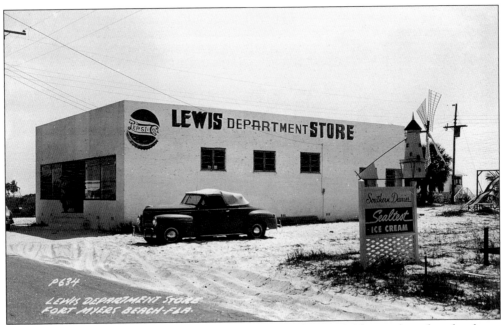

Lewis Department Store opened on November 17, 1946. The store sold everything from hardware to groceries, saving residents many trips to town. Owner Ken Lewis wrote on the back of this postcard: "This picture was taken in January 1948, when we decided to make postcards. Tourists wanted to know why we didn't have postcards of the store so, to please our customers, we had some made and sold thousands at 5¢ each." (EIHS.)

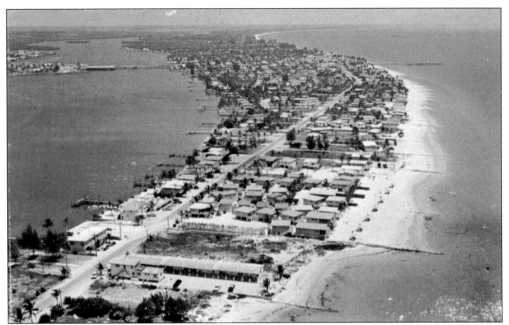

The Pink Shell complex, shown in an aerial view from the 1960s, began in 1953. Roxie Davis Smith, daughter of the owners, told of the family-owned business, "First we had two cottages, then we gradually added more and more cottages. By 1958, we had a cottage colony! We named it Pink Shell because we had all these little cottages and they were all painted pink. At that time we didn't have a bank, we barely had a grocery store, and no place on the island to buy the things you have to have to run a resort." (EIHS.)

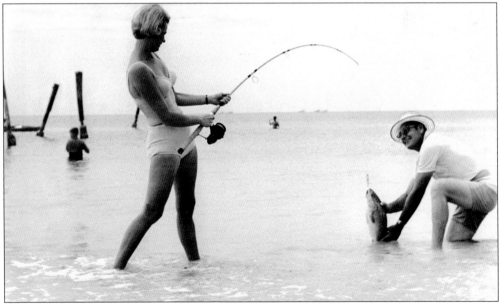

Fishing enthusiasts are a common sight in the gulf along Fort Myers Beach. Roxie Davis Smith and Barney Creech, both year-round Fort Myers Beach residents, are seen here in 1957. In the background are the remaining posts of the first pier, the Winkler Pier, which was destroyed in the hurricane of 1944. (EIHS.)

Betty Lou Knox stands in front of the Fort Myers Beach Garage in 1947. The official US map of 1940 included Fort Myers Beach for the first time. With a population of 473, the island saw a dramatic increase within the following 10 years. A demand for filling stations and garages rose alongside the increase in tourists, new residents, and vehicular traffic. (EIHS.)

Even after a storm—perhaps even more so—searching for seashells was a favorite pastime, as seen in this 1940s photograph of the back of a cottage along Fort Myers Beach. (EIHS.)

The back of this postcard featuring the Seascape Cottages reads, "You may enjoy the comforts of one and two bedroom cottages right on the Gulf of Mexico. Efficiencies with heat, Air-conditioning—and TV—shuffleboard and Bar-B-Que grill. Beautiful white sand beach for fishing, swimming, and shelling. Within walking distance to the fishing pier and shopping." Operated by Hugo and Helen Zantello, this sounded like paradise to servicemen and tourists. (EIHS.)

The Pelican Hotel began as a converted houseboat owned by Anna "Ma" Turner. Built with native lumber, it was made to survive hurricanes as a boat, but served as a "land-based" hotel as well. During World War II, the building and adjoining cottages were used by officers on R&R. An unidentified group poses in front of a Pelican Hotel cottage in this 1940s photograph. (EIHS.)

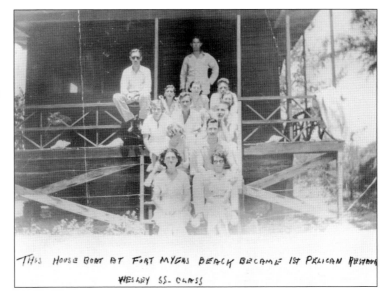

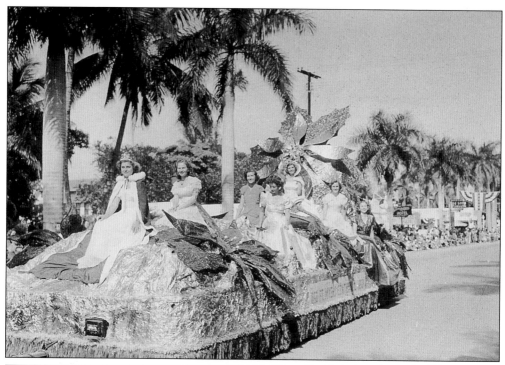

Reminiscing about the February 1950 Edison Day Parade (now called the Edison Pageant of Light), Robley Geddes Greilick described the float carrying Miss Centennial and her court (pictured above) as being light green with huge red poinsettias. She went on to describe her participation in the parade of 1940, "I was in second grade and I walked with the Beach School. I wore a white sailor suit and carried a cardboard streetlight! We walked all the way from the old library on First Street in downtown Fort Myers, all the way to behind the hospital—where they later built Fort Myers High School." Fort Myers Beach teenagers attended Fort Myers High School. At left, posing in formal attire in front of the original monument at Centennial Park in the 1950s are, from left to right, Mary Louise Simpson, Mina Geddes, and unidentified. (Both Geddes collection.)

Charles and Anne Lindbergh (pictured below in the 1950s) enjoyed cruising around the islands of Southwest Florida aboard Jim and Ellie Newton's sailboat (pictured above). Ever the playful jokester, on one voyage Lindbergh painted the mast with molasses while his son Jon was at the top adjusting the rigging. Chuckling, Lindbergh called up to his son, "Now, how will you get down the mast?" Robley recalled times when her mother would come and wake her up and say, "Get up! Someone special is visiting." She went on, "It would usually be Charles Lindbergh sitting at the table chatting with Uncle Jim (Newton)." (Geddes collection.)

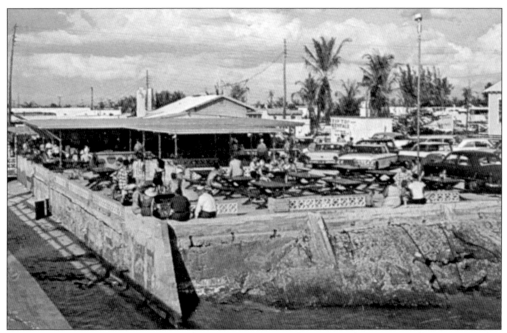

The Tip Top Restaurant was a popular hangout for beachgoers in the 1950s and 1960s. On this 1963 postcard, the shadow of the public pier is visible along the left of the restaurant's concrete seawall and outside deck area. (EIHS.)

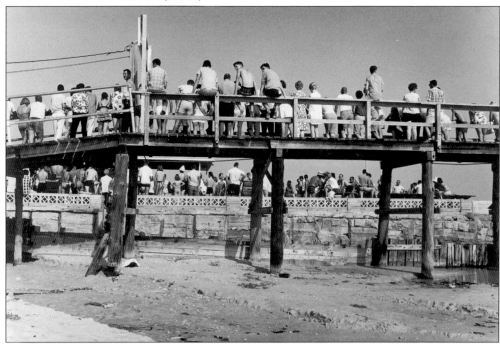

The Fort Myers Beach Public Pier served as choice seating for Beach Day activities. In 1944, the pier received extensive storm damage, and in 1947, a hurricane necessitated its replacement. As shown here in the 1950s, the newly replaced wooden bridge is strong and stable. The Tip Top Restaurant's outside deck is visible beneath the pier as spectators view a beach event. (EIHS.)

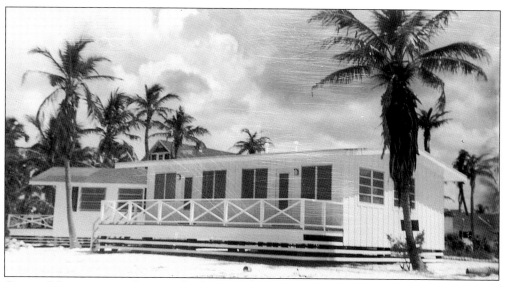

Cottage life meant everything revolved around the beach. Swimsuits were worn all day. Instead of the sunscreen scents of later years, during the 1940s and 1950s, the scent of baby-oiled bodies was prevalent. It was also a time when cottages were known by name rather than address. Grandview Cottage, one of the early cottages built directly on the beach, is shown here as it appeared in 1959. (EIHS.)

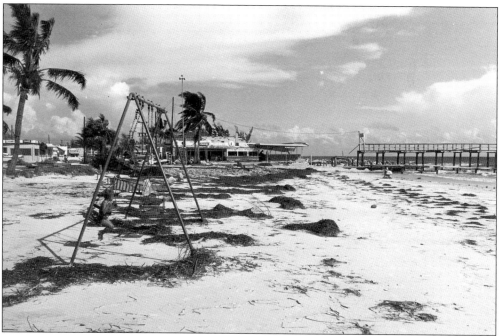

Storms bring back memories to those islanders who have weathered a hurricane or two. Preparing for and living through various storms becomes a way of life. Jo Canady lived in a fish house over the water, where waste water drained right into the bay. Storm surges were known to come right up into the house through the pipes. Homes were not the only casualties following a storm. Here, the beach park at the pier is vacant following Hurricane Donna in 1960. Piles of seaweed and other debris littered the entire length of the island. (EIHS.)

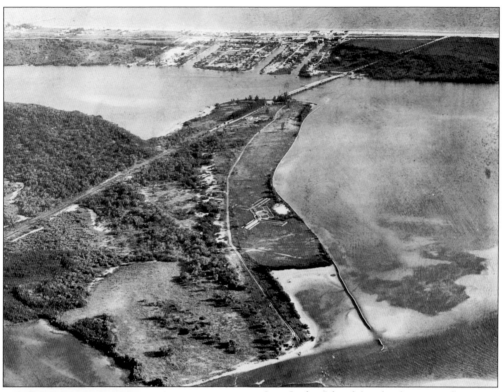

San Carlos Island (in the foreground) is undeveloped in this image showing damage from the 1926 storm. The old road, which existed prior to the construction of San Carlos Boulevard, winds along the island's contour from the lower corner up to the swing bridge. Across the bridge, to the left, are the three canals that existed at that time. (EIHS.)

Primo Drive was the road along the first canal on Fort Myers Beach. Nick and Gertie (Pope) Santini are pictured here in 1947 in the yard of Nick's brother, J. Cyril Santini, on Primo Drive. Cyril was one of the first commercial fishermen to make a home on Fort Myers Beach. (Santini collection.)

Six

FISHING AND SHRIMPING

In 1885, when W.H. Wood caught a tarpon on a rod and reel in Fort Myers Beach, it ignited a fishing frenzy that continues today. Not only did word of the catch spread through the fishing communities on Fort Myers Beach, Punta Rassa, and Pine Island, but eventually, the sport-fishing news traveled worldwide and ignited one of fishing's most popular sports: tarpon fishing. On Fort Myers Beach, former commercial fishermen became charter captains catering to the fishing whims of both visitors and locals interested in catching a tarpon or other elusive native fish. By 1950, curious landlubbers would line up in front of Tarpon Tackle and Hardware awaiting the display of a day's catch from charter boats going out of Snug Harbor. The hardware store hung catches of tarpon in front of the store so everyone could see how the hunt had gone. Island wives learned to create flowers made from the large scales removed from tarpon. Due to the continued popularity of tarpon fishing, the Fort Myers Beach Tarpon Hunters Club was formed in 1961. Charter captains and party boats continue to serve visiting anglers searching for mackerel, trout, grouper, snook, red fish, or tarpon.

Soon after pink shrimp was discovered in the Tortugas in April 1950, dozens of shrimp boats began using Fort Myers Beach as a home port. As many as 150 shrimp boats operated in the Fort Myers and Fort Myers Beach area by 1953. In the same year, the shrimp fishermen brought in 17.32 million pounds of shrimp to the local docks.

According to author Rolphe Schell:

> The shrimping industry brought in many associated industries. Groceries alone were a big item. When the fleet was getting ready to leave for a Campeche, Mexico run, they would literally clean out the grocery stores at the beach. A trip to Campeche required 20 tons of ice, 2,000 gallons of fuel and 80 hours of travel each way for a 17 day trip. Ten nights of fishing would bring in up to 10,000 pounds of headed shrimp (shrimp with heads removed before weighing). Icing was also a problem, necessitating importing ice from as far away as Key West, until an ice house was built on Fort Myers Beach.

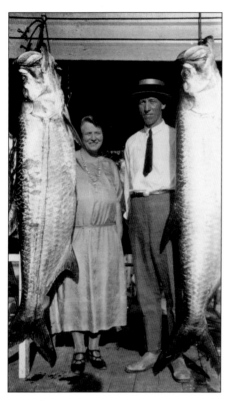

Celebrities such as Thomas Edison and Harvey Firestone fished for prized tarpon in local water throughout the 1900s. According to Keri Hendry, "Newbie Yankee anglers, usually more familiar with salmon fishing, were often left in pain—their knuckles bloodied and raw, when the handles on their reels spun backwards with amazing velocity. The techniques for tarpon fishing are unlike any other in the sport." In this early 1900s image, an unidentified couple stands with tarpon caught off Fort Myers Beach. (KSHSA.)

A goliath grouper, formerly called a "jewfish," looms over both the man and the little girl as it hangs from a rope in this 1915 photograph. Federal fishing regulations now prohibit the catching and/or possession of this gigantic fish. (KSHSA.)

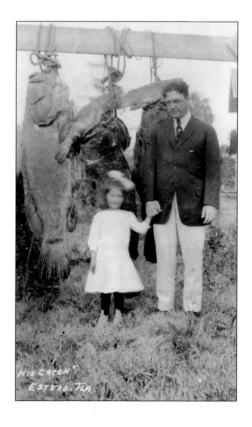

"In place of a rod and reel," Edgar E. Damkohler boasted in a 1948 interview with Tom McEwen, *News-Press* sports editor, "fishermen used the following tackle: 150 feet of heavy cotton line about as thick as a pinky finger, a big hook, a half-mullet, and a heavy key." Fishermen of the 1880s would put the mullet on the hook, toss it out near a sandbar, and coil the remaining line on the water near the skiff. The end of the line was tied to a keg or a heavy log. Damkohler continued, "Once the tarpon hit the mullet and headed away I'd give the line a hard jerk, tightening the hook in the tarpon's mouth. I'd throw the keg overboard, allowing the tarpon to play until tired. I'd follow closely behind in the skiff and when it was apparent the fish had given up, I'd haul it in." Here Captain Damkohler, a noted pioneer of sportsfishing in Southwest Florida, entertains a group of tourists as he guides them on a Caloosahatchee River excursion in the 1950s. (SWFHS.)

Oscar Lybass arrived in the Fort Myers Beach area in 1893 at age 14. As a cattle puncher, Lybass drove cattle to Punta Rassa, where they were loaded onto schooners. After ending his cattle days, he moved to Fort Myers Beach, where he became a commercial fisherman and an outstanding personal guide. In 1974, at the age of 96, Lybass lived alone in a Fort Myers Beach cottage. Reminiscing during an interview with Betsy Goslin, Lybass recalled, "Why, I can remember when Lady Heath (a charter client) would catch a dozen large snook before breakfast right in the clear waters at Snug Harbor. Once, we boated 1,740 pounds of snook, to the annoyance of the other boats!" (EIHS.)

Lybass continued: "This was the best land there was, because you could do what you wanted, when you wanted—as long as you didn't bother nobody. Florida was the greatest land-of-plenty there ever has been but you wouldn't think it now. I saw it changing, and I knew it was changing. But what can a man do?" Guide boats would often turn in to Lybass's place for a "Lybass fresh fish broil." Into his 90s, Lybass would scout the likely holes, catch a mess of pinfish for bait, and, as he shared, "I'd take a run for myself, just to keep the feel and bring home a mess of fresh fish food." In his later years, Lybass, hunched over and wearing khaki pants and a cowboy hat, was frequently seen strolling along Estero Boulevard. After spending 70 years as a Fort Myers Beach resident, Lybass died on the beach in 1975. (EIHS.)

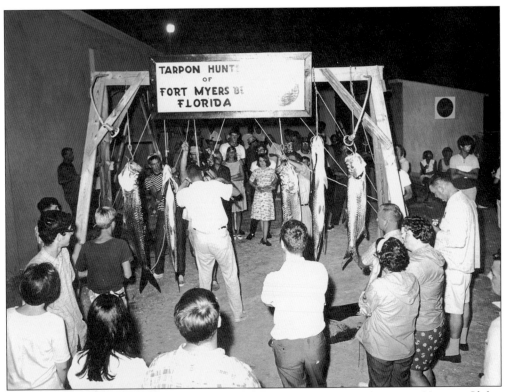

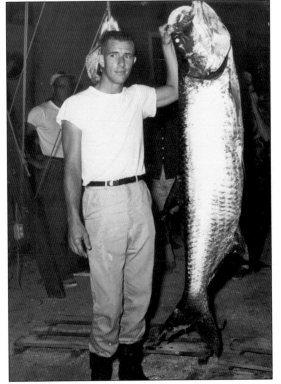

Fort Myers Beach Tarpon Hunters Club member Ray Lister told Keri Hendry in an interview, "Despite its fame, Boca Grande Pass is usually not the hot spot of choice for them. It's absolute madness up there. You can catch just as many fish right off of Ft. Myers Beach." Gary Danis added, "It is amazing what you can run into in just 15 to 20 feet of water off the island. Heck, we've caught 150, 160-pound fish off Bunche Beach!" (EIHS.)

In an interview for the *Island Sand Paper* in 2008, the past president of the Fort Myers Beach Tarpon Hunters Club said, "The club is now involved in tracking tarpon through their DNA. Florida Fish and Wildlife provides kits that contain a vial of solution and a sponge. We wipe the sponge on the inside of the fish's mouth and put it in the vial. Then one of our members sends it back to them and they are able to track the fish—how many times it's been caught and where the fish has traveled." (EIHS.)

Goliath grouper such as this one, caught on Fort Myers Beach, were legal catches in the 1960s. Overfished in the 1970s and 1980s, the goliath grouper population was decimated. In 1990, the fish was added to the federal protection list. (EIHS.)

One thing remained relatively constant during the boom times of the 1950s—fishing! Commercial fishermen netted mullet by the boatload. Out on the flats, small boats with putt-putt hothead engines trolled with several rods offering live bait. And king mackerel were there for the taking when the migrating fish came through the Gulf of Mexico. This display of a day's catch of mackerel was not extraordinary. (EIHS.)

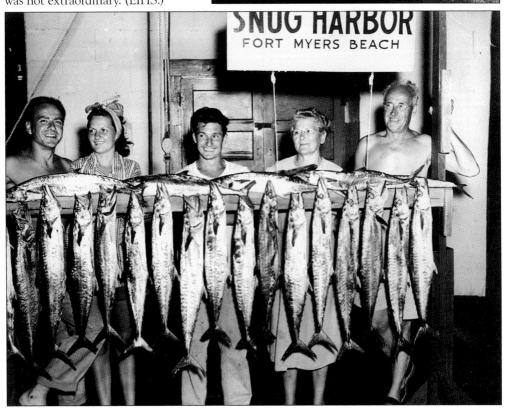

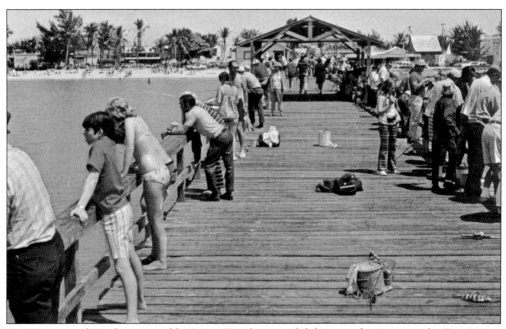

For 41 years, a bait shop owned by Mary Knight served fishing enthusiasts on the Fort Myers Beach Pier. Knight said: "After my husband's death in 1957, the people running the pier then did not think I could run the business on my own, but I outlasted them!" In 1992, 80-year-old Knight said, "I'm tired. I'll miss my friends, but not the hassles." In this image from the 1950s, anglers catch sheepshead fish on the Fort Myers Beach Pier. (EIHS.)

Shipbuilder Donald Kiesel (left) and John Pertrudis (right), a Greek craftsman, built 26 wooden shrimp boats at the boatyard pictured here. Kiesel was known for being the first on the island to own an 80-foot steel boat. He was also the envy of the area's shrimp fishermen when he was the first to boast a freezer boat. Kiesel and Petrudis are pictured with two huge diesel engines awaiting installation in this 1950s photograph. (EIHS.)

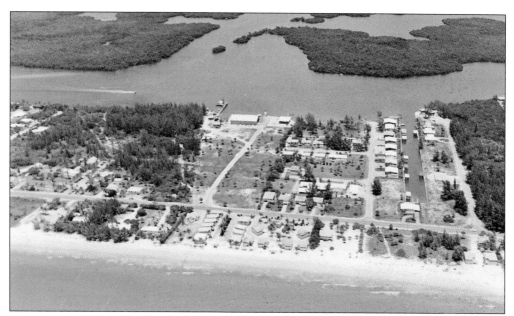

George Sanders had the island's first general store of sorts at his marina on Estero Bay. As an original member of the Koreshan Unity, Sanders arrived on the island around 1919, following World War I. He broke away from the Unity Settlement and independently built and operated Sanders Boat Ways. Sanders ran the boatyard, later called Sanders Boat Yard and Marina, from 1923 to 1978. This aerial view shows Sander's land and marina in the center, appearing as undeveloped land with an angled road leading from Estero Boulevard to the marina buildings. (EIHS.)

Joe and Penny Brown are pictured behind their home on Fort Myers Beach in the 1960s. Standing on the canal seawall, they cast out into the bay and bring in their supper. Perhaps they will need to catch a few more snapper to make it a meal! (EIHS.)

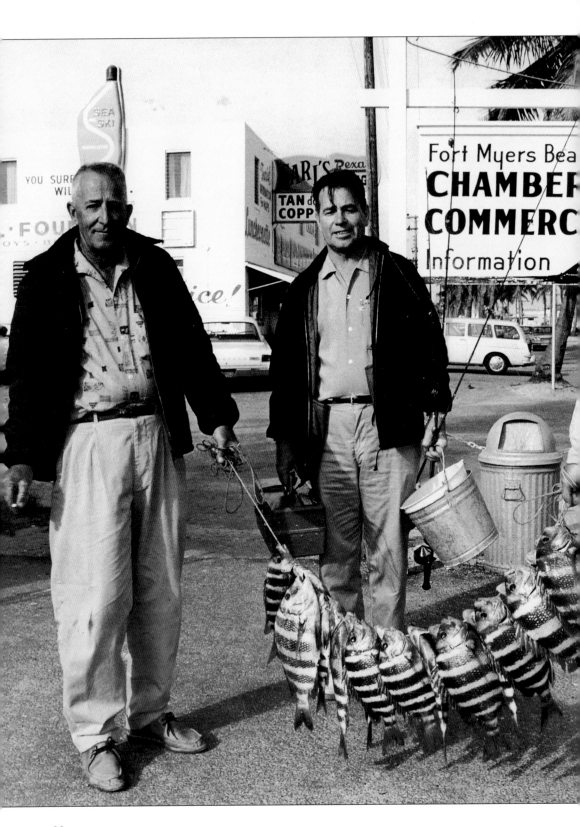

The fishermen in this 1960s image did not need a saltwater fishing license to catch this string of sheepshead, because a license was not required in Florida until 1989. But even in 2011, these men would not be required to have a license if they are Florida residents aged 65 or older. (EIHS.)

In this 1970s photograph, a fisherman weighs his amberjack back at the dock. He may have simply gone out with a charter captain or party boat for a day of sport fishing, or he may have been an entrant in a tournament, as numerous fishing tournaments take place on Fort Myers Beach each year. The sign behind the men appears to indicate that an all-day fishing trip cost $7. (EIHS.)

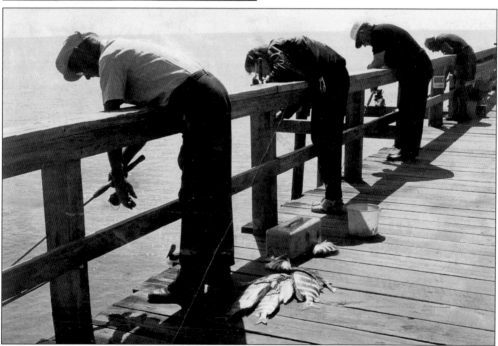

Once fishermen discovered that sheepshead and snook have a preference for hanging out around submerged posts, fishing from bridges and docks became a tradition among both residents and visitors. Vi Stefanich reflected on one outstanding female fisherman: "Barney Creech's mother, Ida, boy was she a good fisherman. She used to go down to the end of the island and get snook! And with all those diamonds all over her fingers—there she was, out there fishing!" Here, several men fish from the Fort Myers Beach Pier in the 1950s, apparently catching no snook, but lots of sheepshead. (EIHS.)

This 1960s-era fisherman sports a sheathed knife and a nice string of fish. Mangroves are visible in the background, indicating he is on the Estero Bay side of the island. Mangroves are essential to the health of the Estero Estuary, as they provide nutritious grounds for young fish and gnarled roots for sand particles to cling to, extending the land mass. (EIHS.)

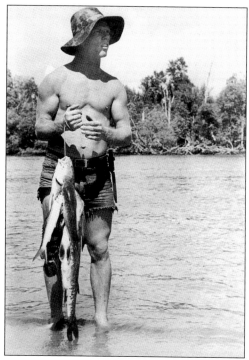

Before electricity came to the island in 1927, islanders relied on iceboxes. "We had an icebox, and the iceman would come by twice a week," said Elizabeth Oakley. With a chuckle and a sigh, she added, "We just left the house open for the iceman. But then, of course, we never did lock our doors at all." By the 1950s the islanders had electricity, providing the residents with their own ice on an as-needed basis. Fishermen no longer traveled to Fort Myers for ice to preserve their catches when J. Cyril and Blanche Santini built the San Carlos Island Ice House, pictured in the 1950s. (EIHS.)

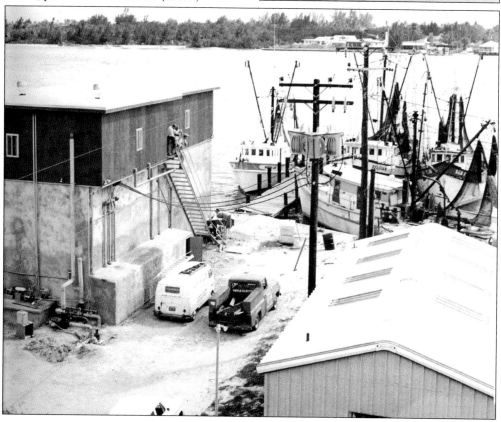

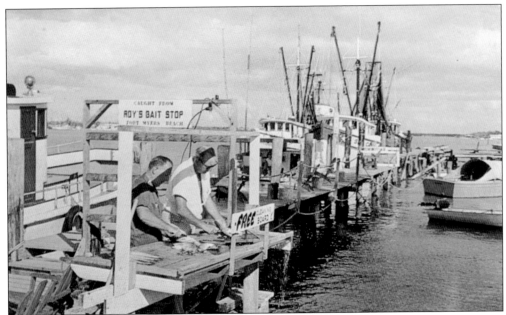

Once caught, fish need to be cleaned. This 1970s photograph shows a fish-cleaning station on the Snug Harbor Marina dock. Private charters, party boats, and shrimp boats all made it a favored place to dock. (EIHS.)

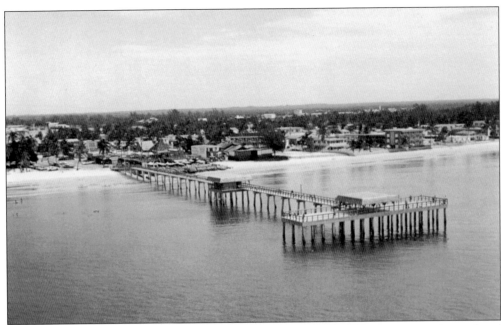

By 1975, the deteriorating wooden public pier maintained by Lee County was condemned and closed to the public. A new concrete pier, pictured here, was completed in 1976, allowing fishermen and tourists to swarm the pier once again to enjoy fishing, socializing, and sunsets. (EIHS.)

Author Jean Gottlieb recalled an interview with Red Russell in which he said, "Mullet was the key fish. There were so many of them in the 1920s and 1930s that with a cast net you could get at least a half a dozen with every cast." Russell went on, "Old-timers like to say, "There were so many mullet back then that they kept me awake at night from all the noise they made jumping and flapping in the water." While fish are no longer found in such abundance, commercial mullet fishing continues. In this 1940s image, an unidentified fisherman weighs his mullet catch at the old Dixie Fish House. (EIHS.)

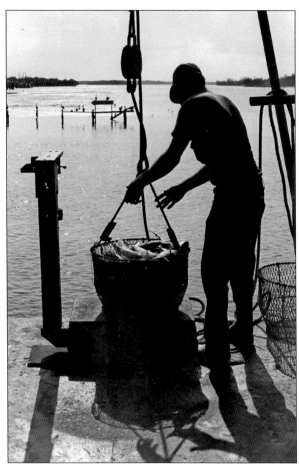

In this pre–Hurricane Donna photograph, the Snug Harbor Marina is ready for business. At the marina, charter captains picked up sport fishermen for a day on the water, marine supplies were available for purchase, and outrageous fish stories were shared on the docks. (EIHS.)

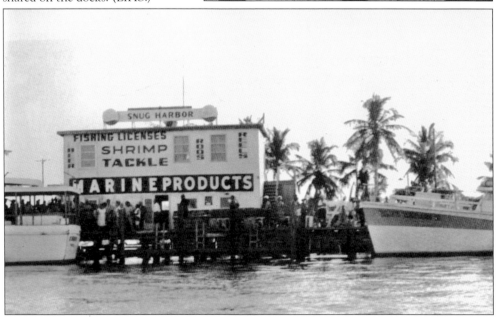

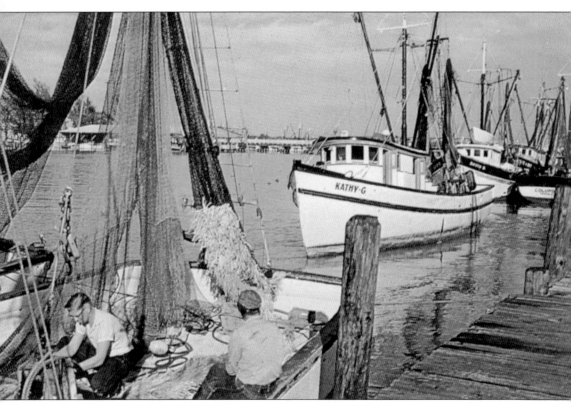

"When I first started out, the trawlers had one big net," Dave Green explained. "Then we went to two great big nets—one on each side; now, they've gone to four big nets, two on each side." The shrimpers shown here in the 1950s are mending nets in preparation for a trip to the Dry Tortugas. (EIHS.)

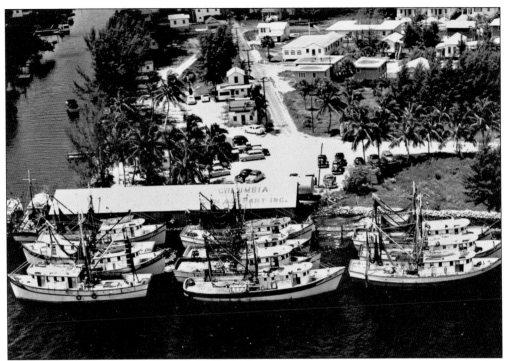

The *St. Petersburg Times* was one of the first to announce the April 1950 discovery of two new shrimp beds in the Tortugas in the Gulf of Mexico. Capt. Sam Vona reported, "Sammy Junior brought in 2,400 pounds and Capt. Walter Floyd on the trawler *Charles Singleton* brought in 2,300 pounds. They said the shrimp were netted from a new bed 'several hours closer' but declined to be more specific. They plan to return there for more." Not only were the shrimp beds closer to Fort Myers Beach, the shrimp were unusually large—about 16 to 18 to the pound, and four and a half inches long without the head. Above, shrimp boats are docked at the Columbia Docks in the 1950s. Below, a lone shrimp boat heads out toward the Gulf in the 1950s. (EIHS.)

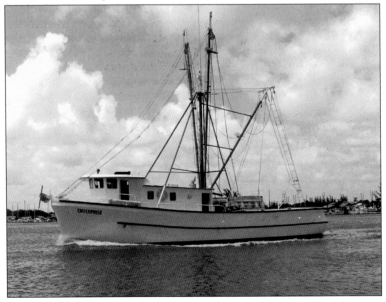

The first Blessing of the Fleet took place at the docks of the Columbia Fish Company on December 21, 1952. Fr. John Hull of the Episcopal church, Charles Green, and John Ferguson organized the event, and Rt. Rev. H.I. Loutitt officiated. The following year, it was decided the event should be held in February, to coincide with the Fort Myers Edison Parade Day, later called the Edison Pageant of Light. This is an unknown artist's sketch of the Blessing of the Fleet. (EIHS.)

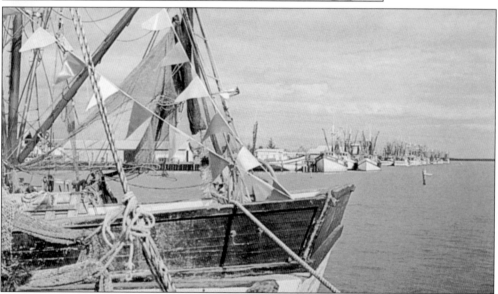

The Blessing of the Fleet is welcomed by fishermen and their families because of the hardships and danger faced while at sea. Although the boat pictured here is festooned with colorful flags in honor of the Blessing of the Fleet, a horrific story appearing in *The Sarasota Herald Tribune* on January 27, 1954, still haunted the area's shrimp docks. The article told of a Fort Myers Beach seaman who fell off a boat while shrimping off the Mexican coast. The body, identified as that of Joseph F. Miller, was found 12 hours later in the shrimp net of another boat. (EIHS.)

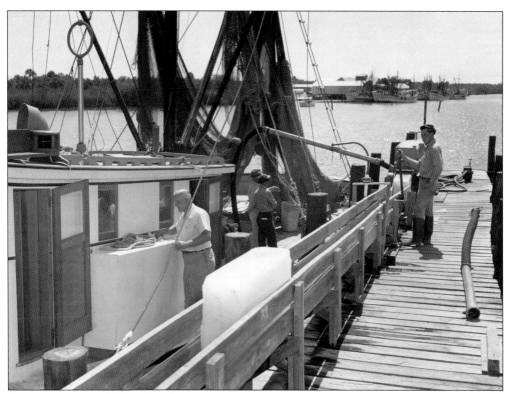

In an interview with Keri Hendry, "Scoop" Kiesel, one of the first shrimpers to go out for the "pink gold," explained how shrimp were kept fresh: "We'd get the ice at the foot of Mango Street. They would put the ice in 300-pound blocks at the main icehouse in downtown Fort Myers. It would be loaded onto a flatbed truck and hauled to the beach, where we'd slide it down the dock to a grinder/mower where it was ground up and blown into the boat via a large, flexible hose. If we made a run to the Dry Tortugas, we'd be gone anywhere from 10 to 12 days, and we'd take eight tons of ice and 1,500 gallons of fuel." In the above photograph from the late 1950s, ice blocks are loaded into a trough chute and then crushed. At right, the crushed ice is blown through the black tube and into the boat's hold. (Both EIHS.)

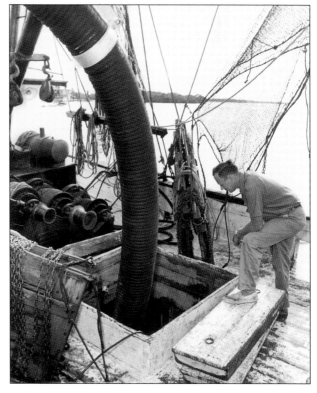

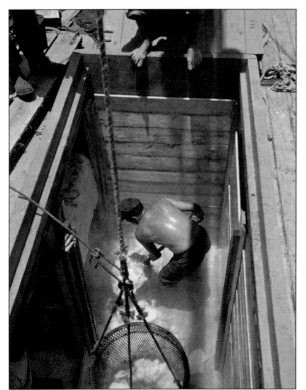

Keeping the netted shrimp fresh was a challenge. David Green recalled: "Originally, each boat had one large hold. It wasn't long until we figured out how to stay out longer. We set up the holds with six or eight bins. We would put each shrimp boat's catch in those separate bins. Then, we sent the shrimp into Fort Myers Beach about once a week—you'd send 'em in with somebody else, and when you came in you'd bring a load of somebody else's. Otherwise you couldn't stay out over a week because the ice wouldn't last." In this image, a crewman shovels ice into empty bins within the hold before leaving for the Dry Tortugas. (EIHS.)

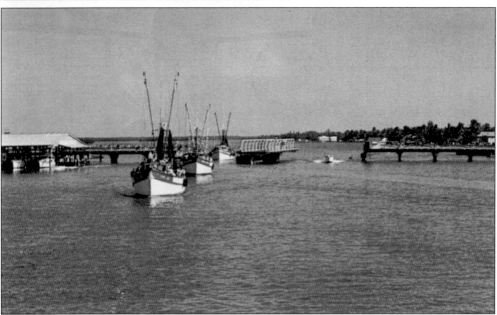

Traffic along San Carlos Boulevard came to a halt as the swing bridge opened to allow a shrimp fleet to begin travel to the Gulf of Mexico and on to the Dry Tortugas. For motorists, it was sometimes an inconvenience, but the majority of the time it was an opportunity to slow down, take in the scenery, and appreciate the good life Fort Myers Beach offers. The shrimp boats pictured are making their way through the pass in the 1960s. (EIHS.)

One of the first items on a shrimper's to-do list on a long haul to the Dry Tortugas was bedding down wherever he could find a spot. The days of letting out and pulling nets were brutal, so resting up was imperative. In this 1950s photograph, a shrimper sleeps on a boat's floor on the way to the Tortugas. (FSA.)

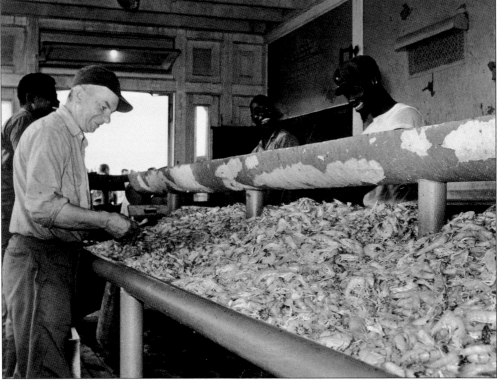

Everyone helped to sort shrimp when a boat came into the docks on Fort Myers Beach; they had to work quickly to prevent spoilage. In this image from 1952, unidentified workers appear to be having a good laugh even though it must have been miserably hot in the sweltering heat of an open building. (EIHS.)

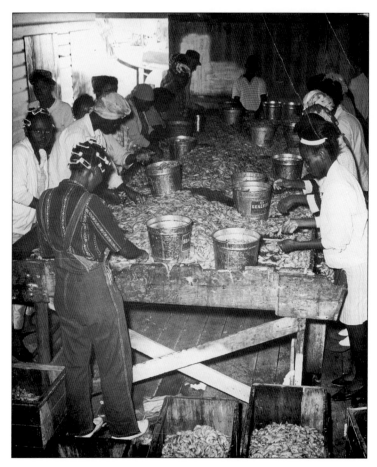

Following the discovery of the new beds in the Dry Tortugas, more than 1,000,000 pounds of shrimp were unloaded at Fort Myers Beach fish houses in the 10 months of the 1950 shrimping season. Beach records show that 1,044,962 pounds were unloaded at the seven houses from 603 trawlers between March 10 and December 31. In December 1950 alone, 60 trawlers unloaded 147,589 pounds of shrimp, with three boats bringing in 6,626 pounds in the last week of the month. Pictured here in the 1950s, workers on Fort Myers Beach sort and rate shrimp piled on wooden benches. (EIHS.)

Maurice Thomassin arrived on Fort Myers Beach in 1950, just after pink shrimp was discovered in the Gulf of Mexico. Thomassin explained the packing procedure shown here: "In the early 1950s, there was no freezer here. Two or three times a week, the shrimp buyers came and the shrimp were crated and shipped by boat or truck. There would be 100 pounds of shrimp packed in layers of ice in each crate." Thomassin recalled that dealers paid 38¢ per pound in 1954. (EIHS.)

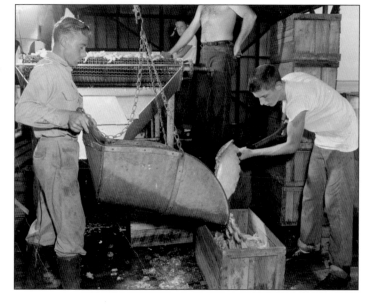

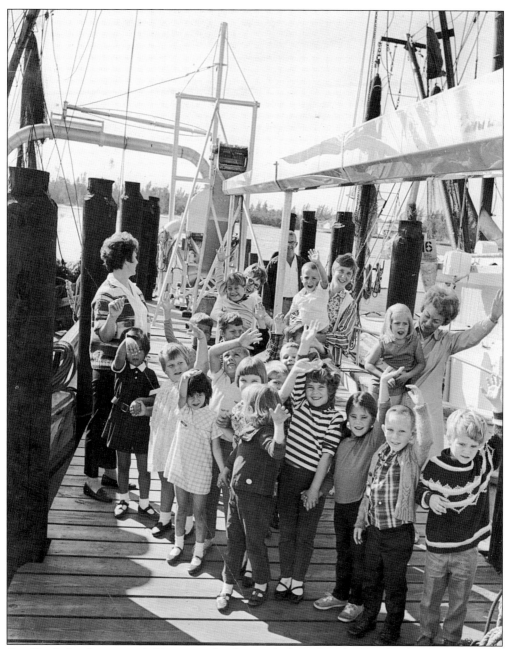

San Castle kindergarten children visit the shrimp dock on San Carlos Island in the 1950s. Not only did this field trip teach the students about the shrimp industry in general, it also educated them about a business vital to the island's livelihood. (EIHS.)

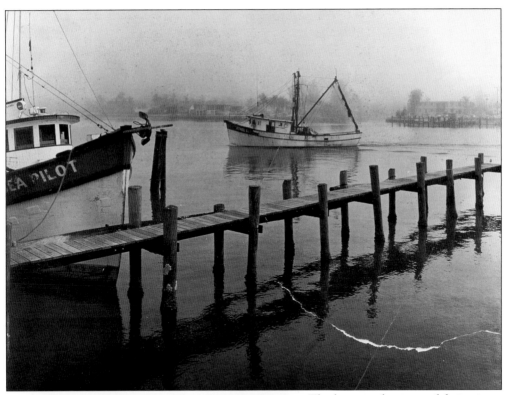

The lucrative business of shrimping began to decline in 1977 following a drastic drop in wholesale prices, when shrimp went from $3.80 to $2.80 per pound. Expectations soared when prices were back up within a year. However, the most fatal blow to the industry came when, in 1980, the Campeche fishing grounds were closed. The 25-year shrimping industry on Fort Myers Beach would never return to the glory days of the 1950s. In this image, shrimp boats remain idle at the docks. In later years, shrimpers relied on smaller bait shrimp for income and pink shrimp became a seasonal bonus side catch. (EIHS.)

Fishing comes in many forms on Fort Myers Beach, from commercial net fishing to chartered fishing adventures to standing at the end of a lone dock. (EIHS.)

Seven

PLAYGROUND BY THE SEA

Put simply, there is nothing quite like Fort Myers Beach. There is a sense of community within the small-town atmosphere. The beauty of the beach and the serenity of the bay, the hometown businesses, and the recreational activities enchant those who visit the island. The beach contains great restaurants serving freshly caught seafood, while Times Square and Lynn Hall Memorial Park offer gulf-side fun. Farther down the island, Matanzas Pass Wilderness Preserve, located at the end of Bay Street, offers a taste of what the island was like before man arrived. By the 1970s, condominiums and cottages sat side by side along Estero Boulevard, and seasonal and second-home buyers could purchase a piece of paradise. In the 1980s, conservation efforts increased as the state of Florida purchased Lovers Key and Black Island, including Carl Johnson Par, and created Lovers Key State Park. At Bowditch Point, 17 acres were added and the Beach Pool, Bay Oaks, and Matanzas Pass Preserve became parks and recreation facilities.

From the 1960s into the 21st century, visitors have recognized a feeling that this place was expecting them and that they were supposed to be here. Could it be the oddly familiar smell of the salty breeze and the difficulty of breathing through the humidity of moist velvet that casts the spell? Or could it be the musky wet smells of the mangroves that lure the soul to stay? Whatever it is, Fort Myers Beach is a melting pot of different races and religions. The voices of tourists and locals fill the sidewalks, shops, and open-air restaurants. The blare of music from passing cars dragging Estero Boulevard during spring break may jar older ears, yet it too is part of what makes Fort Myers Beach what it is. It never takes too long for a visitor to kick off his or her city shoes and go native while at the playground by the sea.

The Fort Myers Beach Chamber of Commerce broke away from the Lee County Chamber of Commerce and became an independent entity in February 1974. The organization promotes beach businesses and activities, bringing prestigious events, such as the sand sculpting competition, to the island. The Fort Myers Beach Chamber of Commerce is no longer confined to the tiny office shown here in the 1960s, but is now located in a large, contemporary building on San Carlos Boulevard. (EIHS.)

In July 1963, an official Coast Guard station houseboat, completely air-conditioned and comfortably furnished, was installed at Fort Myers Beach Marina on San Carlos Island for an estimated cost of $50,000. In 2005, the Coast Guard occupied this building in the same location. (EIHS.)

After purchasing the entire south end of the island from the Koreshans, Leonard Santini began to develop the land for both residents and winter visitors seeking a seasonal beach retreat. In January 1969, it was announced that Leonardo Arms Condominiums had made over $600,000 in presales. Santini also built Santini Plaza and many other island buildings. This photograph shows the grand opening of the Leonardo Arms Condominiums, the first condominiums on Fort Myers Beach. Standing on the stairs leading into the front entrance to the condominiums during the 1970 grand opening function are, from left to right, Leonard Santini, Jim Newton, and Jim Sweeny. (EIHS.)

This postcard depicting the south end of Fort Myers Beach shows the Creciente and Leonardo Arms condominiums in the 1980s. In March 1969, Leonard Santini offered Fort Myers Beach residents access from Estero Boulevard to the bay for a proposed mid-island bridge, but there were no takers. (EIHS.)

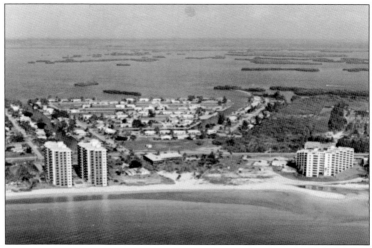

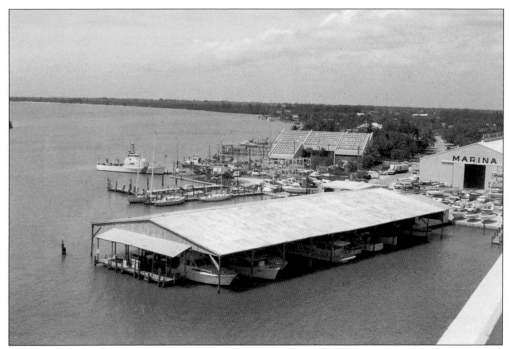

Looking north from the Sky Bridge in 1980, the Fort Myers Beach Marina on San Carlos Island is in the foreground and the Coast Guard Station is farther north. Before the permanent Coast Guard building was constructed in 1963, an air-conditioned houseboat served as headquarters, on guard 24 hours a day, seven days a week, defending and protecting against drugs, illegal immigrants, and smuggling, as well as protecting boaters from harm. (EIHS.)

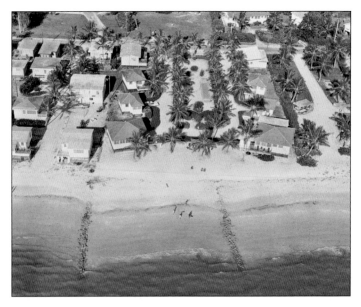

The Pink Shell Cottages are shown here to the left of the Kohler Cottages in the 1970s. The Pink Shell cottages were sold to the Mariner Corporation and then gradually moved off the property to make room for high-rise buildings. Roxie Smith, daughter of the original owners, preserved a cottage and relocated it to the bay side. Receiving historic building recognition from the Town of Fort Myers Beach, this cottage brings back happy memories of beach vacations. (EIHS.)

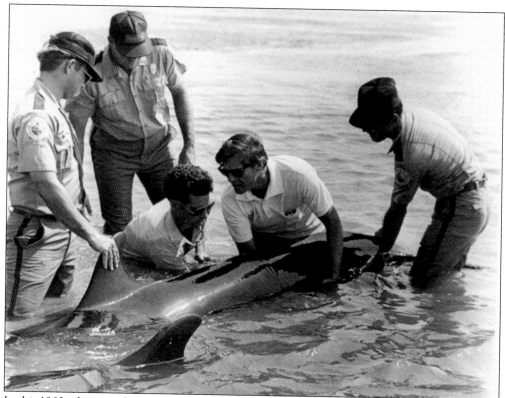

In this 1960s photograph, rescuers attempt to turn beached pilot whales toward the gulf and safety. Concerned residents, including Jean Gottlieb, and tourists kept the mammals wet by splashing them with water until Sonny Burnett, from the Coast Guard, moved the lead whale out into the water and the others followed. Although rare, whales occasionally beach themselves on Southwest Florida's beaches. Pilot whales also beached on Little Estero Island on June 2, 1986. (EIHS.)

With the inaugural event held in 1958, The Fort Myers Beach Lyons Club continues to sponsor the annual Island Shrimp Festival. The 1962 Island Shrimp Festival queen was Pam Lewis, shown here in the festival directory. (EIHS.)

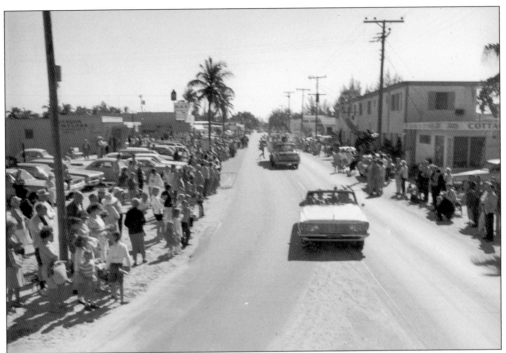

Beach Day included a parade along Estero Boulevard in the 1960s. Later named the Annual Shrimp Festival, it always brought out the crowds. In 1964, Beach Day had a record crowd of 25,000, only equaled by a Blue Angels performance the same year. The above image shows the parade route along Estero Boulevard. Below, two unidentified girls sport bikinis and fishing poles as they ride on the hood of a car in a 1960s parade. The "float" advertises Fort Myers Beach, the Cove Marina, the Spinaker Restaurant, and the Beach Taxi Company. (EIHS.)

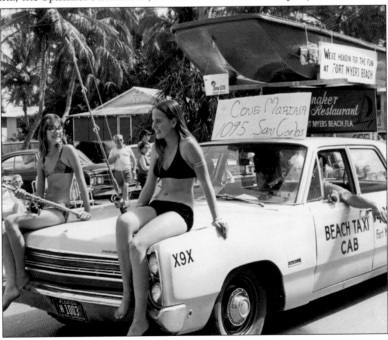

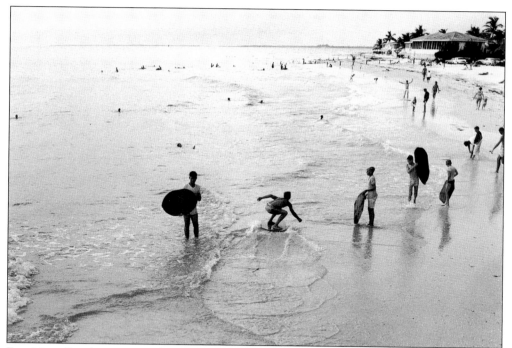

Fort Myers Beach possesses a key element for a perfect skimboard ride: gentle waves. With hard, smooth sand beneath the waves, and the absence of dropoffs or riptides, skimboarders have found Fort Myers Beach to be a near-perfect skimboard paradise. To the delight of beach visitors, skimboarder enthusiasts provide a non-stop show in this 1960s photograph. (EIHS.)

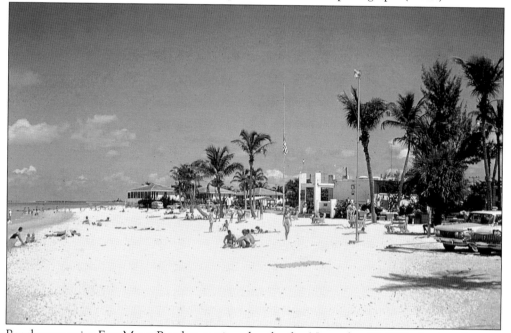

Beachgoers enjoy Fort Myers Beach sometime shortly after November 22, 1963; the time frame is apparent because the American flag is flying at half-mast in recognition of the mourning period following the assassination of Pres. John F. Kennedy. (EIHS.)

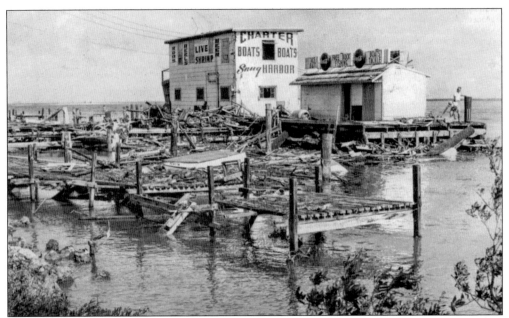

Fort Myers Beach caught the brunt of Hurricane Donna in the late summer of 1960. Winds gusted to over 120 miles per hour and tides ran up to seven feet above normal. The winds uprooted scores of trees and stripped the leaves and fruit off of others. Donna left shattered windows, unroofed houses, and downed power lines in her wake; lives, too, were shattered—three deaths were reported in neighboring Bonita Springs. Here, Snug Harbor Marina appears in near ruin after being hit by Hurricane Donna. (EIHS.)

In the days following Hurricane Donna, the swing bridge was kept in an open position (as shown) to keep looters off the island. Marci Santini Hallock said: "I can remember Daddy getting stopped at the wooden bridge by law enforcement and him trying to prove residency by pointing to our house, right there by the bridge." Chester Keene explained to Hallock, "Well, you needed the 'code name' to get back on the island. It was 'Little Red Hen.' " The 1928 bridge had a tendency to get stuck in the open position, causing major traffic headaches for motorists. (EIHS.)

The year 2004 will be remembered as the year of the hurricanes—Charley, Jeanne, Francis, and Wilma all paid a visit. The beaches suffered major erosion, with average losses of 28 feet. The more significant impacts were experienced at the north end of the island, where erosion exceeded 100 feet in some areas. Storm surge levels for the island reached eight feet. After the storms, debris was cleared away and the displaced sand was moved to eroded areas. Here, a man lounges on the beach behind the Lani Kai Hotel as a loader works on restoring the beach. (EIHS.)

For these 1960s sunbathers, there was most likely no thought of the organized preservation of Fort Myers Beach. In the 1980s, conservation efforts increased as the state of Florida purchased Lovers Key and Black Island, including Carl Johnson Park, and created Lovers Key State Park. (EIHS.)

Metal detectors, like the one this beachgoer is using, became popular in the 1970s when a drop in cost made it possible for just about anyone to own one. People with dreams of finding lost treasures such as rings or coins were often seen scanning for treasure on local beaches. (EIHS.)

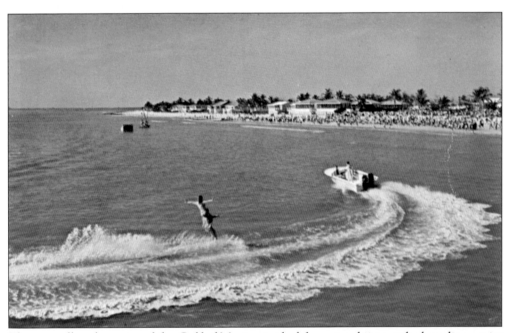

The normally calm water of the Gulf of Mexico is ideal for water skiing, wake boarding, or jet skiing. Resorts along the beach offer jet ski rentals and parasailing adventures for visitors tired of simply sunbathing on the beach. A couple of skiers perform for a beach crowd in this 1960s postcard image. (EIHS.)

In August 1962, construction began at the south end of the island on the causeways and bridges to connect Fort Myers Beach with Bonita Beach via Black Island. On July 4, 1965, the formal opening made travel possible from US highway 41 through Bonita Beach to the island. As Lee County residents discovered the new route, traffic on Estero Boulevard increased considerably. (EIHS.)

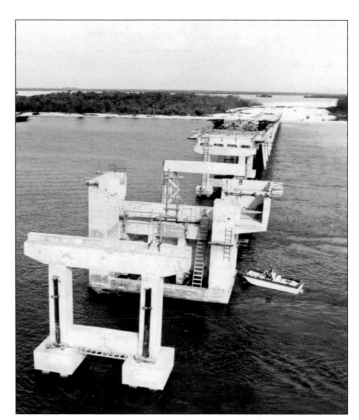

In an effort to limit congestion on Estero Boulevard, a trolley system began on Fort Myers Beach in 2002. The service was free for visitors or residents, with a pick-up/parking area located off the island. Public beach access areas were also established along the entire length of the island. The accesses not only provided visitors with ample parking, but also short distances to walk to the beach. (EIHS.)

In this image from the 1990s, Jim Newton and his wife, Ellie, sit near the Fort Myers statue/fountain dedicated to the Uncommon Friends. Jim Newton was born in 1905 and had a long, distinguished career as real estate developer, conservationist, cowboy, soldier, corporate executive, labor dispute negotiator, and loyal friend. Newton's book based on his diaries, recollections, and extensive correspondence, *Uncommon Friends*, is a tribute to the lives of five of his personal friends who also happened to be national heroes: Thomas Edison, Henry Ford, Harvey Firestone, Alexis Carrel, and Charles Lindbergh. (Geddes collection.)

The Ocean Harbor Condominium and Marina complex, pictured here, was completed in 1991. On the back of this postcard was written: "Admidst a grove of palms, quava and banana trees, you'll find plans ranging up to 3,600 square feet. The glorious views of both the Gulf of Mexico and the sparkling Estero Bay can be enjoyed. The perfect setting for the rest of your life." Landscaping efforts by Town of Fort Myers Beach city planners and developers have encouraged new developments to maintain a tropical setting. (EIHS.)

After several failed attempts, the Town of Fort Myers Beach became incorporated in 1995. By 2000, the Fort Myers Beach Comprehensive Plan became effective. In this 1970s photograph, students at the Beach Elementary School learn about the importance of the island's past as they study a map of early island homesteads. (EIHS.)

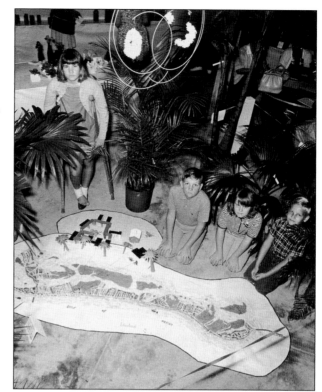

A young man takes advantage of the carefree beach atmosphere to perform some skimboard antics to the delight of onlookers in the 1960s. (EIHS.)

The Estero Island Historic Society was started in 1991 by a group of island residents with an ardent desire to preserve the history of the island. The mission of the organization is twofold—to preserve the island's history and to share historical knowledge with others. In 1994, the group acquired the Davison Cottage (originally the Sand Castle Kindergarten) to serve as the museum. The property adjoins the Matanzas Pass Preserve. The museum and annex are pictured here in 2005. (EIHS.)

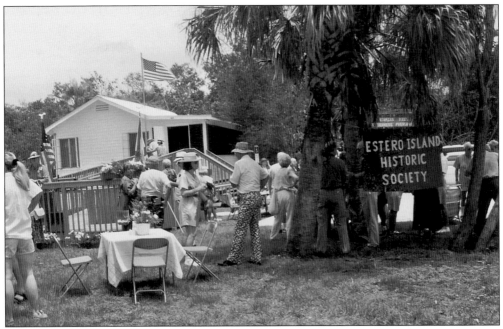

Guests enjoy refreshments during the official dedication of the Estero Island Historic Society and Nature Center in 1997. The organization collects written and oral histories that capture the social spirit and development of Fort Myers Beach as it evolved from a sparse barrier island to a popular tourist destination. (EIHS.)

Bibliography

Andrews, Allen H. *A Yank Pioneer in Florida*. Fort Myers Beach, FL: Island Press, 1980.

Barnes, Jay. *Florida's Hurricane History*. Chapel Hill, NC: The University of North Carolina Press, 1998.

Brown, Barrett and M. Adelaide. *A Short History of Fort Myers Beach*. Fort Myers Beach, FL: Estero Island Publishers, 1965.

Damkohler, E.E. *Estero, Fla., 1882: Memoirs of the First Settler*. Fort Myers Beach, FL: Island Press, 1967.

Edic, Robert F. *Fisherfolk of Charlotte Harbor, Florida*. Gainesville, FL: IAPS Books, 1996.

Fernandez, Pamela. *Beside The Still Waters: The Story of the Fernandez Family of Estero*. Fort Myers, FL: Press Printing, 2010.

Fritz, Florence. *Unknown Florida*. Coral Gables, FL: University of Miami Press, 1963.

Gottlieb, Jean S. *Coconuts and Coquinas: Island Life on Fort Myers Beach, 1920–1970*. Tallahassee, FL: Sentry Press, 1999.

Johnson, Darlene Horne. *Evelyn Luettich Horne: Classic Recipes and Memories of an Estero Legend*. Fort Myers, FL: Press Printing Company, 2006.

Lamoreaux, Leroy. *Early Days on Estero Island: An Old Timer Reminisces*. Fort Myers Beach, FL: Estero Island Publishers, 1967.

Pearse, Eleanor H.D. *Florida's Vanishing Era: From the Journals of a Young Girl and her Father, 1887 to 1910*. Tampa, FL: Privately published, 1954.

Schell, Rolfe F. *History of Fort Myers Beach, Florida*. Fort Myers Beach, FL: Island Press, 1980.

Discover Thousands of Local History Books
Featuring Millions of Vintage Images

Arcadia Publishing, the leading local history publisher in the United States, is committed to making history accessible and meaningful through publishing books that celebrate and preserve the heritage of America's people and places.

Find more books like this at
www.arcadiapublishing.com

Search for your hometown history, your old stomping grounds, and even your favorite sports team.